Playful Painting

PEOPLE

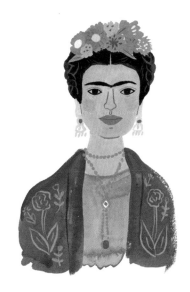

WHIMSICAL PROJECTS AND CLEVER TECHNIQUES FOR PAINTING ANY LIKENESS—
from family and friends to the rich and famous

SARAH WALSH

Brimming with creative inspiration, how-to projects, and useful information to enrich your everyday life, Quarto Knows is a favorite destination for those pursuing their interests and passions. Visit our site and dig deeper with our books into your area of interest: Quarto Creates, Quarto Cooks, Quarto Homes, Quarto Lives, Quarto Drives, Quarto Explores, Quarto Gifts, or Quarto Kids.

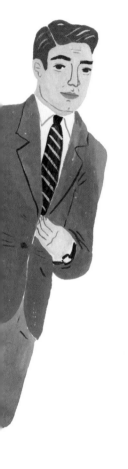

© 2018 Quarto Publishing Group USA Inc.

Artwork and text © 2018 Sarah Walsh, except photo on page 144 © Lauren Pusateri

First published in 2018 by Walter Foster Publishing, an imprint of The Quarto Group. 6 Orchard Road, Suite 100, Lake Forest, CA 92630, USA.
T (949) 380-7510 **F** (949) 380-7575 **www.QuartoKnows.com**

Walter Foster Publishing titles are also available at discount for retail, wholesale, promotional, and bulk purchase. For details, contact the Special Sales Manager by email at specialsales@quarto.com or by mail at The Quarto Group, Attn: Special Sales Manager, 401 Second Avenue North, Suite 310, Minneapolis, MN 55401 USA.

ISBN: 978-1-63322-469-8

Digital edition published in 2018
eISBN: 978-1-63322-470-4

Page Layout: Krista Joy Johnson

Printed in China
10 9 8 7 6 5 4 3 2 1

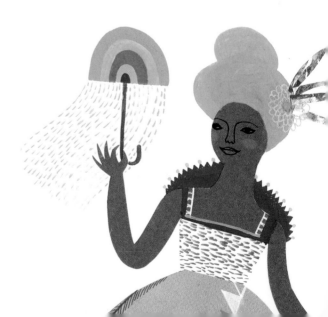

PEOPLE

WHIMSICAL PROJECTS AND CLEVER TECHNIQUES FOR PAINTING ANY LIKENESS—

from family and friends to the rich and famous

TABLE OF CONTENTS

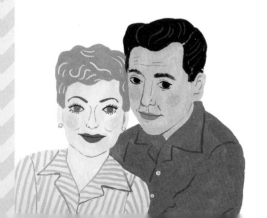

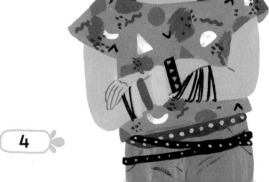

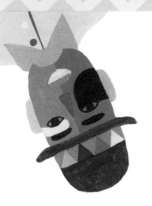

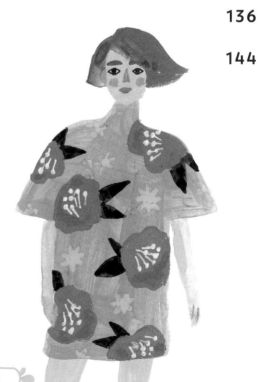

INTRODUCTION

Painting portraits may sound a little intimidating, right?

Capturing someone's likeness can be difficult, even for the most seasoned artist. But wait: I have good news! It's not just a person's likeness that you're capturing. It's that person's energy, essence, and even soul. Sounds a bit creepy, I know. But what I mean to say is that a portrait is about how you *see* that person, which means it's up for interpretation. Everyone's interpretation will look different, and that's what makes portrait painting so fun.

If you like to make your art look realistic, pay attention to proportions, face shapes, hairstyles, and any distinctive features. I cover those topics in this book along with simple drawing and painting tips; different ways to create noses, eyes, and hairstyles; which materials to use; and how to use color to create dynamic portraits.

If you're new to portraying people, the step-by-step projects in this book will help you grow comfortable painting portraits in no time. Some people like having their portrait painted. It makes them feel special and like you're really trying to "see" them, so ask around, and find people to paint!

With your newfound skills, you can paint your family members, your friends, or even a stranger on the train. But don't let that person catch you, or he or she may try to take you home to paint the whole family!

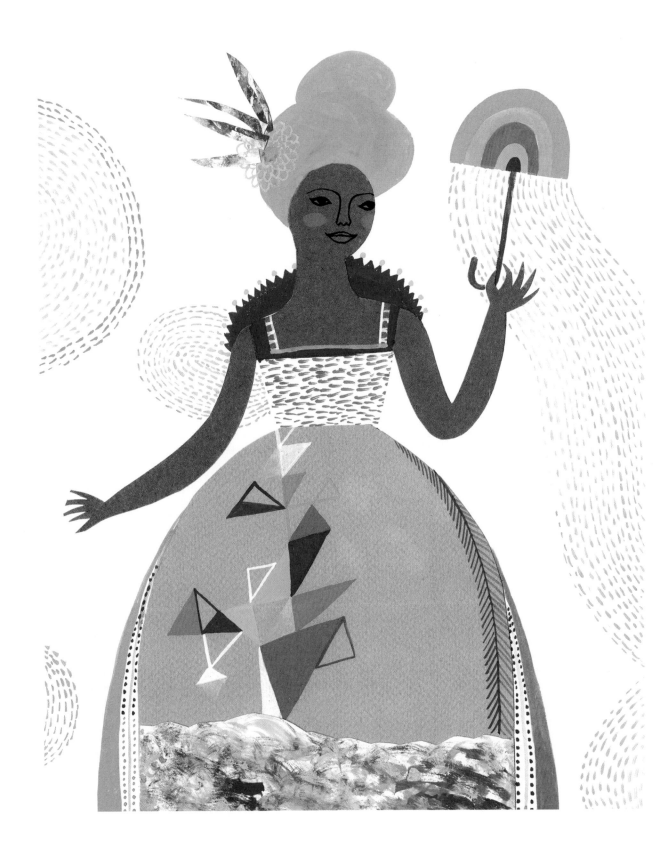

TOOLS & MATERIALS

My favorite medium has always been gouache, and it was pretty much my entry point into the painting world. I have a bit of a confession, though: When I first became a working artist, my medium was the computer. Although I drew everything with pencil, it became a finished piece only through that glowing screen. Then, a few years ago, I started dabbling in painting.

The process was slow and inconsistent, and I was afraid to make mistakes, but being off the computer was so refreshing and fun. The more I painted, the more my confidence grew, and the looser and bolder I became. Relishing in the mistakes and imperfections that happened along the way were all part of the journey.

On the following pages, I'll share the tools and materials that I use to create my fun, stylized portraits.

PAINTBRUSHES

Begin with the following simple set of brushes: a large round brush, a medium-sized round brush, a medium-sized pointy brush, and a small fine-tipped brush.

Watercolor brushes are too delicate for acrylic and gouache paints; I prefer to use synthetic mixed-media brushes.

● ● ● ● ● ● ● ● ● ● ● ● ●

I call my medium round brush "old reliable" because it's so versatile. You can even use it to create a fine line by stroking lightly at a steep angle.

PAINT

I usually paint with gouache, which is similar to watercolor and, in fact, is sometimes called "opaque watercolor." You can use water- or acrylic-based gouache paints. I use both—sometimes together! Water-based gouache paint functions more like watercolor, although its colors are less vibrant. I've spent hours mixing paints to achieve the right color! Acrylic gouache colors are gorgeous right out of the tube, however.

A big difference between water- and acrylic-based gouache is the way they dry. Unlike water-based paints that can reactivate with water, acrylic-based gouache dries to a water-resistant finish.

PALETTE

A paint palette is a surface for mixing paint colors. There are many different kinds of palettes available, from plastic- and metal-welled palettes to disposable paper palettes. I prefer disposable ones (which I reuse), as acrylic paint is difficult to clean out of the non-disposable kind. Some artists will add fresh paint on top of the dried water-based gouache on a palette and simply reconstitute with water to use it again.

WATER

Have at least two water jars on hand: one for your lighter paint colors and another one for the darks. It's important to start off with clean water, but truth be told, my water is fairly dirty most of the time!

PAPER TOWEL

I always paint with a thick stack of paper towels next to me. I'm constantly wiping off my brush after dipping it into water to avoid having a brush that is too wet.

This is one of my most important painting lessons. I've been burned so many times by a stray blob of water that makes its way down the brush as I'm painting a fine line.

PAINTING SURFACES

If you're just learning to paint, cheap paper may be the best surface for you. There's nothing like a beautiful, expensive piece of paper to make you nervous. Cheap paper is accessible and unintimidating, allowing you to feel free to create something gorgeous.

Your paper should be thick so it doesn't buckle under the moisture of your paint. Make sure to experiment with different types of paper, however. I like something with minimal tooth (meaning it's smooth), as I create a lot of fine lines in my artwork, and paint can catch on heavier-toothed paper.

A mixed-media sketchbook is a great place to start.

MIXED MEDIA

COLORED PENCILS
Colored pencils can add texture to your artwork, creating interesting contrasts against smoother strokes and washes of paint. Try using watercolor pencils, which behave like watercolor paint with the addition of water.

> I love to use many forms of media in one piece to add interest and texture.

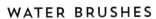

WATER BRUSHES
These are fun to play with if you want a washy, watery look in your art. Try different thicknesses to find your favorite.

GEL PENS
I love adding fine-lined details to my pieces. Gel pens are the perfect tool for this because they have opaque ink that works well over paint, and they come in all sorts of colors!

PAINTING & DRAWING TIPS & TECHNIQUES

In "Tools & Materials" (page 8), I introduced you to my various drawing and painting apparatuses, including paintbrushes, gouache paint, gel pens, paper, and more. Now let's learn how to use these tools and others to create textures, layers, washes, and other effects in your portraits.

Colored Pencil Techniques

MONOCHROMATIC GLOW
To create a rich and vibrant effect, grab two colored pencils from the same color family (see page 19). First use the lighter-toned pencil, and then loosely stroke over it with the darker pencil so that some of the brighter color shows through.

HATCH MARKS
These add fun and texture to a piece. Try drawing them in different directions!

COLORING IN ROWS
With thoughtful coloring, you can add visual interest to your artwork by letting some of the white of the paper show through each row of color, creating a subtle pattern.

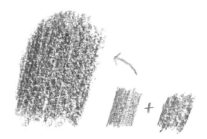

COMPLEMENTARY COLOR OVERLAY
Layer a warm color over its cool complement to create a vibrating effect.

Painting Techniques

OPAQUE
Use a solid application of color for a graphic look.

OPAQUE WASH
Fill your brush with paint and apply it to your sheet of paper, moving downward. Then dip your brush in water, and finish the shape. The water will puddle slightly to create a beautifully imperfect effect.

WATERY MARK
This effect requires a little paint and a lot of water. Dip your brush in paint, and then add a generous amount of water before stroking on the paper. Use more or less paint versus water to create your desired effect.

COLOR BLENDING
Apply paint to your paper with a downward motion. Then dip your brush in water, and add liquid to the bottom of the painted area. Dip your brush in another color to fill in the watery shape. The colors will blend and the liquid will create blooms and irregular edges in the paint.

OMBRE
Using a slightly wet brush loaded with color, create a shape. Then rinse your brush, dip it in another color, and stroke along the top of the shape. The colors will bleed a little or a lot depending on how much water you add.

DRYBRUSHING

This technique requires a relatively dry brush with just a bit of paint on it. Try adding different amounts of paint to your brush for various effects, such as scratchy, distressed textures.

TONE-ON-TONE DETAILING

Start with one paint color, let it dry, and then add a lighter or darker color on top for detailing.

UNDERPAINTING

Use a bright paint color to make a mark. Let it dry completely, and then use a dry brush and a darker color over your original shade. But don't cover it completely! The messier, the better; you want the first shade to peek through.

STIPPLING

Using a medium-sized round brush and a test sheet of paper, make little dots. For a perfectly round dot, pay attention to how you hold the brush and rotate its nib.

Stippling can be used to add a pattern and fill an object with color.

> **Make sure your paint is completely dry before applying anything over it.**

Mixed-Media Techniques

SIDE-BY-SIDE

I like to place gouache next to colored pencil for a side-by-side, smooth-and-scratchy effect. Try different colors, and apply varying amounts of pressure with the colored pencil.

GEL EFFECT

I love using gel pens on top of acrylic gouache. They go on smoothly and allow you to doodle over the paint. Gel pens also create a fine line that's easier to control than when using a brush.

PENCIL DETAILING

Apply a smooth layer of paint, and then add scratchy pencil marks on top for an eye-catching effect.

Watch your elbows and forearms! It's easy to forget what you're doing and put your arm in a place that you just painted while trying to reach another spot. If you're right-handed, work from left to right and high to low. If you're left-handed, work from right to left and low to high.

COLOR THEORY BASICS

Color is a strong component in my work. I love featuring unexpected color combinations or using analogous colors (see page 18 for more on these) with a pop of a complementary color.

Color is a big topic; we could spend the rest of our lives exploring just color. If that seems intimidating, you're not alone.

For now, let's start with one basic tool for understanding color. I'm referring to the color wheel, of course!

Understanding color relationships through the wheel will give you the confidence to express yourself using color and to experiment with various color stories. Now let's meet our color wheel friends!

Primary Colors

Red, blue, and yellow are the three primary colors; all other colors stem from these. Primary colors can't be created by mixing other colors.

> **You can think of the primary colors as the roots of a family tree.**

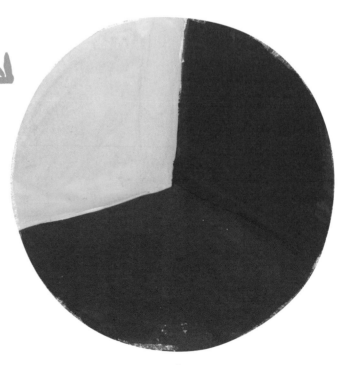

Primary Color Wheel

Secondary Colors

Orange, green, and purple are secondary colors; they are made by combining primary colors.

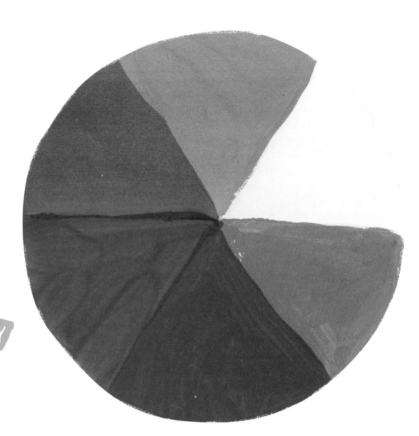

Secondary Color Wheel

Tertiary Colors

Tertiary colors are formed when you mix a secondary color with a primary. These include red-orange, yellow-orange, blue-purple, blue-green, red-purple, and yellow-green.

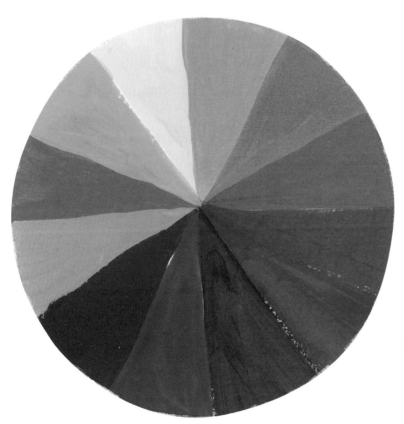

Tertiary Color Wheel

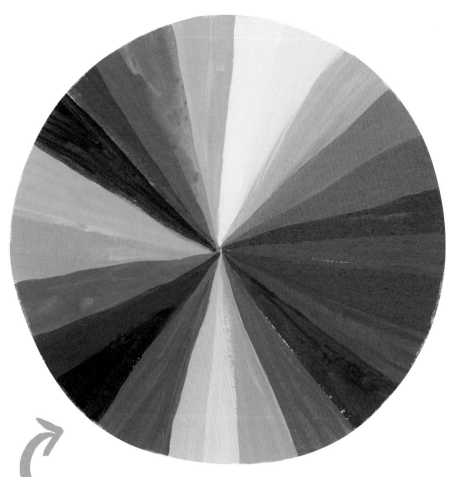

Here is a color wheel based on the tertiary color wheel, along with some of my favorite hues.

Analogous Colors

These are any three colors that sit side-by-side on a 12-sectioned color wheel.

• • • • • • • • •

Add a complementary color to an analogous color scheme for a fun combination!

Complementary Colors

These colors sit directly opposite from each other on the color wheel. Complementary colors make the colors around them look brighter—so bright they can almost appear to vibrate.

• • • • • • • • •

You can lower the saturation of a color by adding white and just a touch of black or another complementary color.

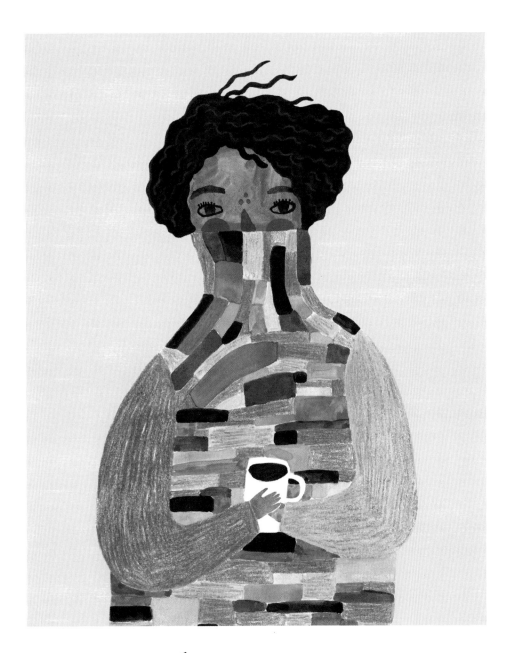

More Color Terms

Hue refers to the purest form of a color, without lightening or darkening it. The 12-hue color wheel (shown on page 17 as the tertiary color wheel) is a way to see the most common hues. Remember that there can be many hues within a color family. For example, ultramarine and cerulean are both blue, but they are different hues. (Ultramarine leans toward purple on the wheel, whereas cerulean leans toward green.)

You can create variations of a hue by lightening it, darkening it, or changing its saturation (or chroma). Adding white to a color makes a tint, adding black makes a shade, and adding gray makes a tone.

Value is a term used to describe the lightness or darkness of a color or black.

In this painting, I used a variety of hues, values, tints, shades, and tones to create an eclectic, eye-catching pattern full of contrast.

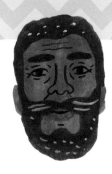

ABOUT FACE

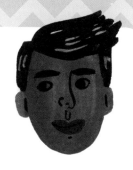

Here are a few basic tips to keep in mind when you are ready to begin painting portraits.

Observation is key. What do you see first when you look at a person's face? Pay attention to any prominent features, unique attributes, eyewear and style (if applicable), chin size, and anything else that stands out.

There are also a few important elements that must be included in any portrait, no matter what your subject looks like.

FACE SHAPE
Some people have round or heart-shaped faces, while others display a squared-off jaw.

HAIRSTYLE
There's an endless list of hairstyles to paint, from mullets and ponytails to bangs and buzzcuts. If you can nail your subject's hair, then you're well on your way to creating a successful portrait!

SKIN TONE
Play around with conventional as well as unconventional skin tones, depending on how realistic you want your portrait to look.

EYEBROWS
The shape and thickness or thinness of a person's eyebrows can really change his or her overall appearance, so don't be afraid to experiment.

EYES
How far apart are your subject's eyes? Eye shape is important as well.

NOSE
The nose is a prominent feature on any person's face. How big is your subject's nose? Is it wide or thin, and what do the nostrils look like?

MOUTH
Some people have wide mouths with thick lips, while others have skinny or even pinched-looking lips. The bow-shaped mouth is one of my personal favorites to paint.

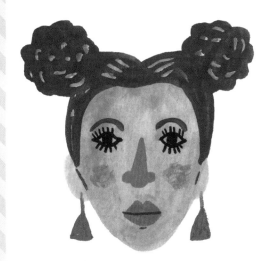
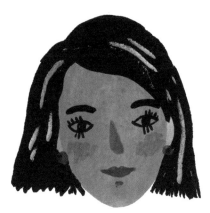
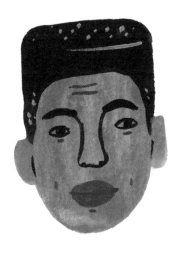
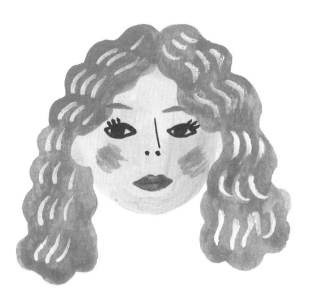
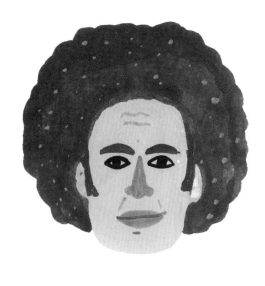
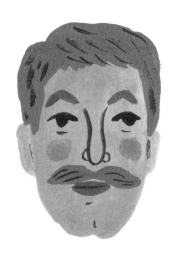

Hand-Lettered Woman

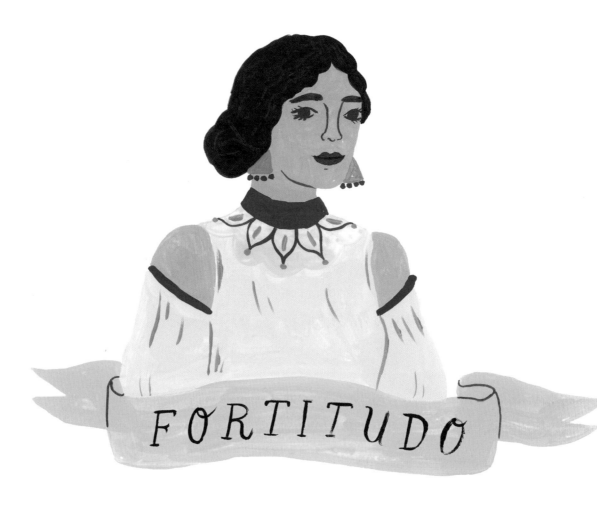

FORTITUDO

Words can be very powerful. And when those words are paired with a strong, beautiful woman who stands for something, it's an unbeatable combination that creates a dynamic visual story.

Now, let's paint our banner beauty and add some hand-lettered fun.

"Fortitudo" means "courage" in Latin.

STEP 1

Mix up a peach-toned skin color, and grab a medium-sized round brush. Start by painting the part in the woman's hair and work your way down to her face, leaving an area white for her lips. Add her bare shoulders.

Rinse out your paintbrush, and reload it with a mint green color to paint the woman's blouse. Paint around the scalloped neckline and leave white stripes for the piping on her sleeves.

● ● ● ● ● ● ● ● ● ● ● ● ●

Using a bright tone as an underpainting allows the brightness to shine through and create a rich, beautiful effect.

STEP 2

Now use a reddish-brown color for her eyebrows and hair. This hair color will serve as an underpainting for the darker color that you will add in step 3. Let the paint dry completely.

STEP 3

Paint the pink banner at the bottom of the piece. Then, using dark brown paint and a partially dry brush, fill in the woman's hair, letting some of the original red peek through. The messier, the better!

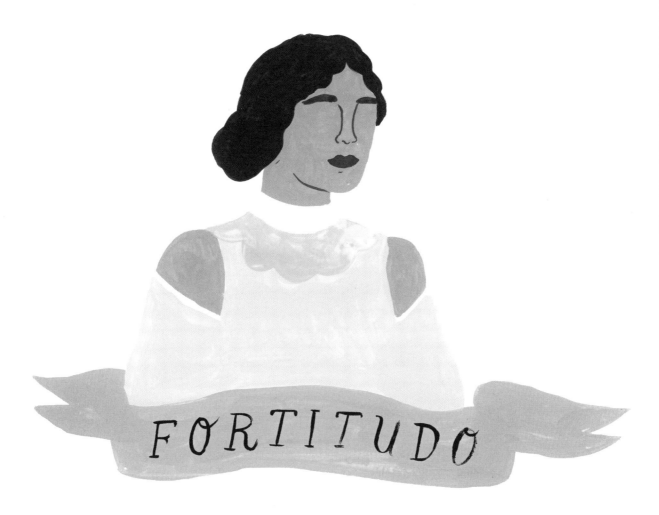

STEP 4

With a fine-tipped brush and the reddish-brown color you used in step 2, add the woman's nose. Without rinsing the brush, load it with red and paint her lips.

Use a medium-sized round brush and blue-gray paint to add her scalloped collar.

With a pencil, lightly write in the word of your choice. Make sure you're satisfied with how it looks, and then go over the pencil with a black fine-tipped pen.

You can write "fortitudo" on your banner as well, or choose your own favorite motivational word or phrase!

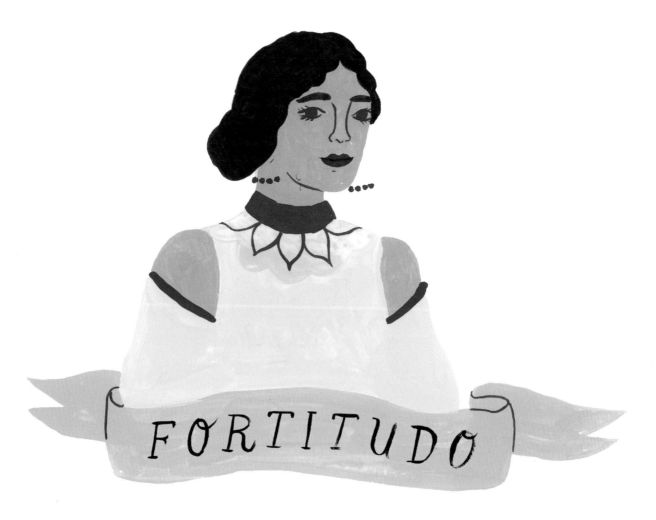

FORTITUDO

STEP 5

This electric blue is one of my all-time favorite colors. Use a fine-tipped brush to add the woman's eyes and detailing to her earrings and collar. Then, with a thicker brush and the same color, add the woman's collar and the piping on her sleeves.

With a clean fine-tipped brush, add red lines to define the banner.

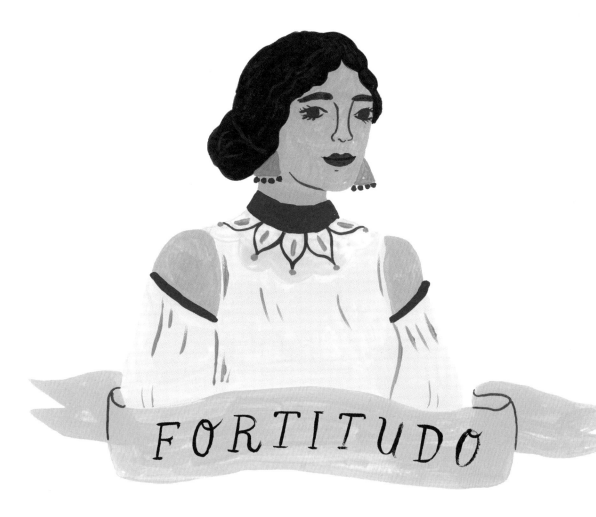

FORTITUDO

STEP 6

She's almost done! Use mustard yellow to paint the woman's earrings and the details on her collar. Then grab a dark green color and add the folds in her blouse with thin strokes. Finish up the painting by adding some red line work in her hair.

And now your strong, brave banner beauty is complete!

A Portrait of a Man Indoors

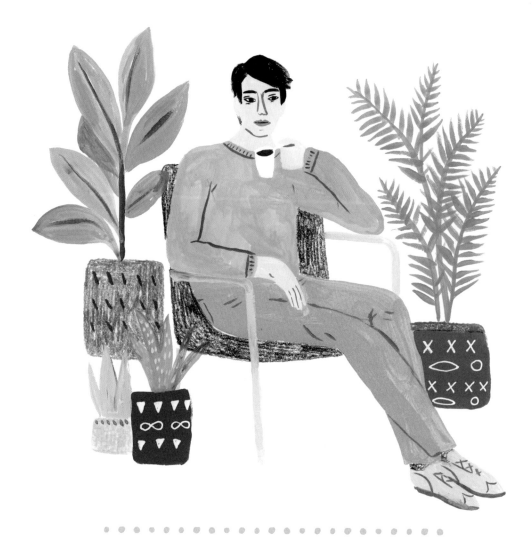

Plants are a lot of fun to paint. From their many-colored pots to the shapes and textures of their leaves, plants give you the opportunity to explore and play while painting. Throw in a handsome modern man with good taste and a hot cup of coffee, and you're all set for a fun little painting adventure!

Blue and yellow are both primary colors and make for a bright, happy-looking color combination.

STEP 1

Grab a large brush, and paint the man's pants mustard yellow. Keep this paint on your palette for later use.

Rinse the brush, and then paint his sweater a bright sky blue. Leave negative space for his coffee cup and hand. Keep this paint on your palette as well.

Now add the man's head and hands using a smaller round brush and a pale peach paint mixed with a bit of yellow. Again, save this paint on your palette.

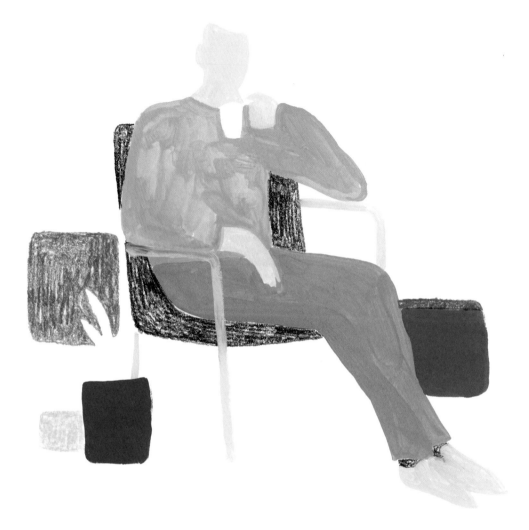

STEP 2

Mix darker blue into the bright blue paint you used in step 1, and add a plant pot next to the man's leg. Rinse your paintbrush, add more dark blue to the same paint mixture, and paint a second pot on the other side of the man.

With a black colored pencil, fill in the shape of the chair and the man's socks.

Then use a red colored pencil to draw another pot and a stripe along the top of one of the blue pots.

Use a pink colored pencil to create the smallest pot.

With a medium-sized brush and blue-gray paint, add the chair's armrests and legs and the man's shoes.

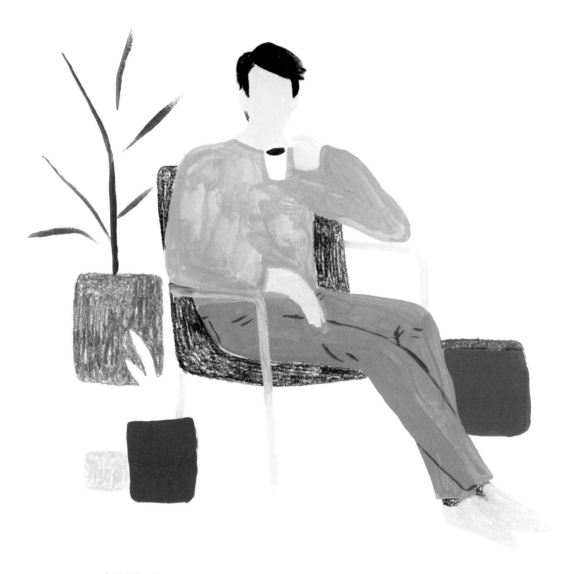

STEP 3

Working again with the medium-sized brush, use red-brown paint to create a stem for the plant in the red pot.

Mix in a touch of black to create a dark brown color for the coffee in the man's cup.

Use black paint to add his hair. Switch to your fine-tipped brush and mix black with a bit of the mustard yellow on your palette. Define the man's pants with thin lines.

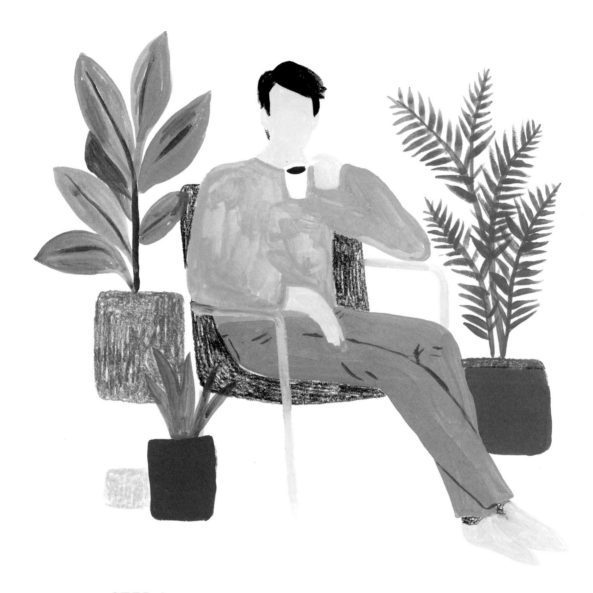

STEP 4

It's time to add leaves to your plants! With sage green, add the plant in the red pot. Use a slightly dry brush to give the leaves texture. Let the paint dry, and then add some brighter green leaves for variety.

Use the same bright green color and a smaller brush to paint the plant in the small blue pot.

Now add the palm fronds (see "Palm Procedures" for tips). First, paint the five main stalks of the palm, and then add the blades.

Palm Procedures

Getting skinny palm fronds just right can be tricky, so practice painting these here before adding them to your final painting.

Each blade of the frond is one stroke of a paintbrush. To create a blade, load a small brush with bright green paint. Begin the base of each blade along the center stalk. Start each stroke with heavy pressure, and then reduce the pressure as you move upward. As the leaf thins, lift up the brush to form the point. This may take a bit of practice.

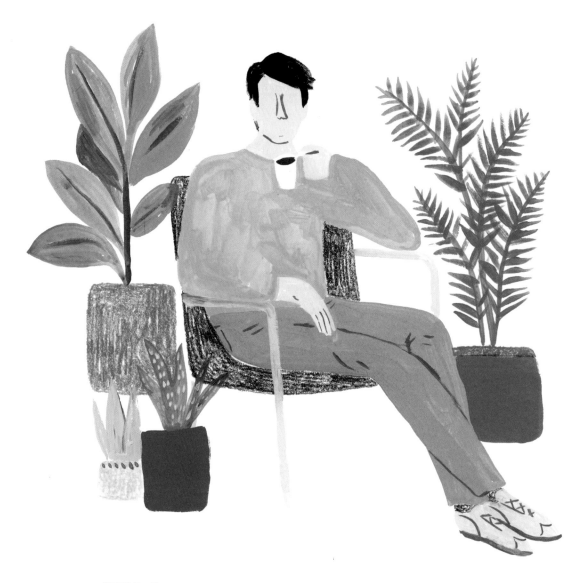

STEP 5

Use a medium-sized brush and light green paint to add the plant in the pink pot. Also add little dots to the plant next to it for texture.

Now use a small fine-tipped brush and a muddy peachy-brown color to add details to the pink pot as well as the man's face, hands, and shoes. Don't forget the wingtip detailing on his shoes for a stylish touch!

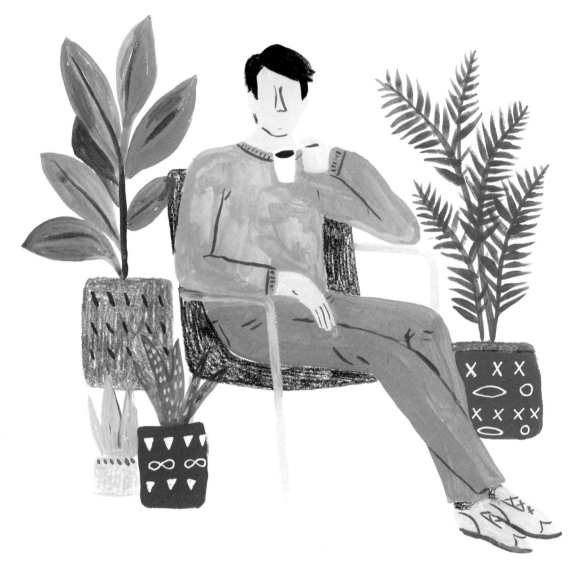

STEP 6

Using a gel pen and moving from left to right (or right to left if you're left-handed), add patterns to your pots. Let the ink dry, and then use a fine-tipped brush and blue paint to add a pattern to the red pot and the line details on the man's shirt. I love these two blues together!

I love using white gel pens over acrylic gouache paint. The ink goes on smoothly and adds a nice pop of contrast.

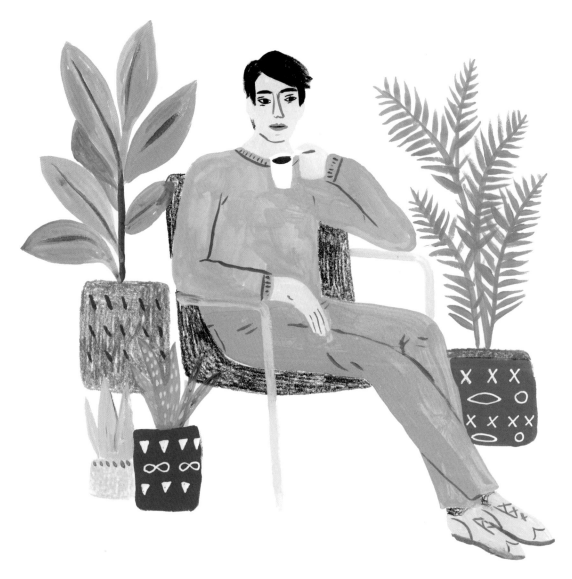

STEP 7

Now for the last step! Grab your fine-tipped brush and mix the skin color you reserved during step 1 with a touch of dark brown paint. Add the man's lips.

Then, using black paint, add his eyes, eyebrows, and lip crease.

You're all done! Let your subject relax, sip his strong brew, and admire his beautiful houseplants.

Mixed-Media Methods

For more on using gel pens and colored pencils over paint, see "Painting & Drawing Tips & Techniques" on pages 12–15. Vary your patterns and techniques next time you're adding details to plant pots! Try the patterns here, or create your own below.

Mixed-Media Frida Kahlo

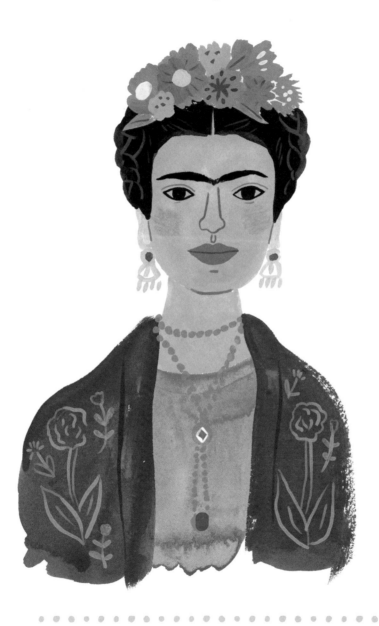

Frida Kahlo was a beautiful woman with striking features. A Mexican artist who painted many self-portraits before her early death in 1954, Kahlo had distinctive eyebrows and hair. Keep those in mind as you paint her.

STEP 1

Mix up a combination of white, water-based gouache and acrylic gouache in ash yellow, flesh, and yellow ochre.

Using a medium-sized round brush and this paint mixture, form an oval with a squared-off jaw. Add ears and then fill in the neck, curving the bottom. Allow the paint to dry completely.

• • • • • • • • • • •

Gouache paint dries to a darker color than it appears when wet, so create a few test swatches of your paint mixture before you jump in and begin painting a portrait.

STEP 2

Mix together wine red and magenta acrylic gouache paints, and create Frida's shawl.

• • • • • • • • • • • •

**Let the tip of your paintbrush
dry out a bit to create broken
strokes, which suggest
an interesting texture.**

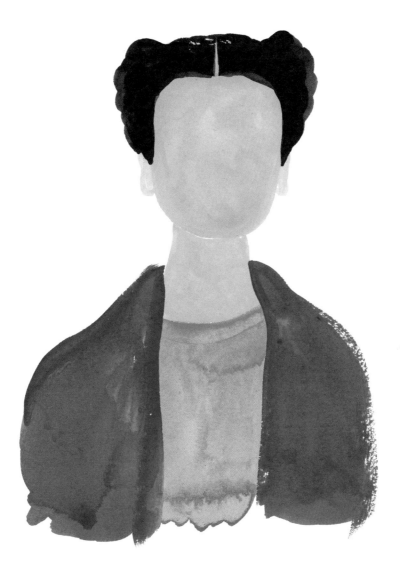

STEP 3

Use cerulean blue paint for Frida's shirt. For a fluid-looking edge, add more water to your paintbrush.

Now let's paint the hair! Frida Kahlo often wore her hair in braids that were tied up on her head and decorated with flowers.

Using your medium-sized round brush and black paint, create Frida's signature hairstyle. Don't forget to include her middle-part!

STEP 4

Adding flowers to Frida's hair is one of my favorite steps in the painting process. Grab your fine-tipped paintbrush and white, pink, deep rose, coral, olive green, and mustard yellow paint colors.

Keep your paint fairly thick, add the biggest flowers first, going from left to right (or right to left if you're left-handed). Then add the leaves and smaller flowers.

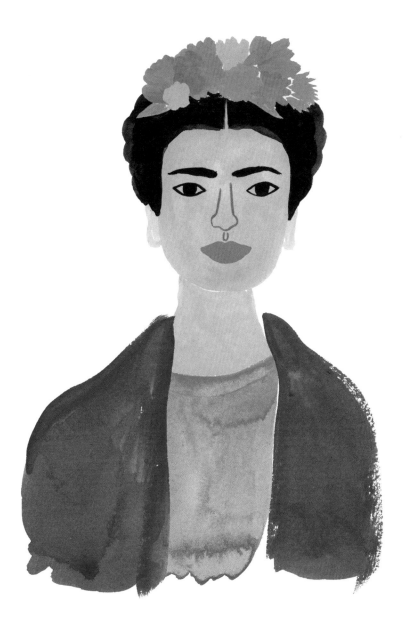

STEP 5

Now for Frida's gorgeous face! Take out your fine-tipped brush, and dip it in black paint. Start with her eyebrows. Then move on to her eyes.

Clean your brush thoroughly, mix up a darker version of Frida's skin tone from step 1, and create her nose. Use your medium-sized round brush again with some coral paint to add her lips.

● ● ● ● ● ● ● ● ● ● ● ●

I like to start with the thick end of the eyebrow and stroke toward the thin end.

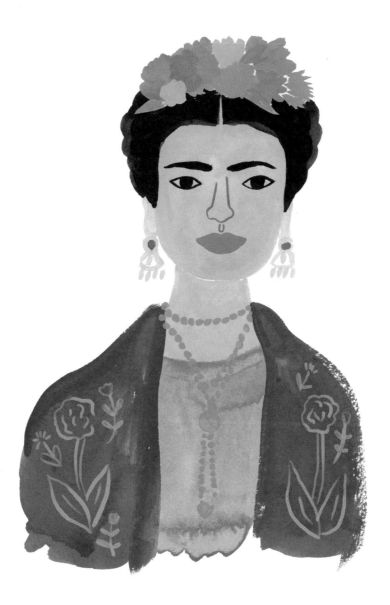

STEP 6

Frida Kahlo wore beautiful jewelry, so let's bedazzle her! You can use my instructions, or feel free to create your own jewelry if you prefer. Just remember that if you use dots for her necklace, like I did, you'll want to use a medium-sized round brush for a successful dotting technique.

Mix mustard yellow, yellow ochre, and white to create a gold-toned paint. Then create designs on her shawl using a fine-tipped brush and pink paint.

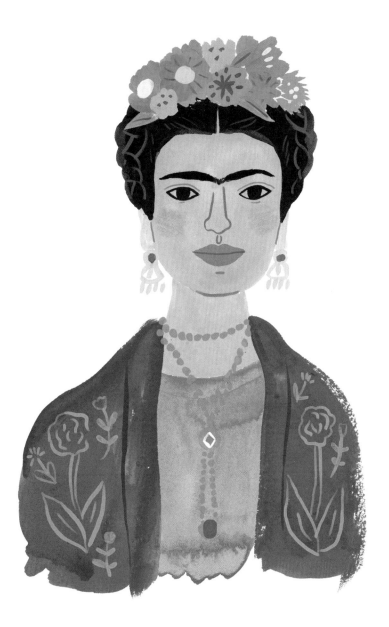

STEP 7

Now for the details that will pull together your portrait! First, let's add color to Frida's cheeks with a coral colored pencil.

Then use a fine-tipped brush and the paint colors of your choice to create details on the flowers. I used dark blue, deep rose, white, and mustard yellow.

Use light blue paint to create braids in Frida's hair and the big stone in her necklace. With deep rose, create a line to define her lips, and add folds to her shawl. Use lighter pink paint to add a jewel in her necklace.

Now on to my favorite part of the painting: Frida's unibrow! Use a fairly dry paintbrush to form little lines and build a bridge between her brows.

You're done! How does she look? I'm sure you've captured Frida's beauty in your own special and amazing way.

High-Fashion Girl

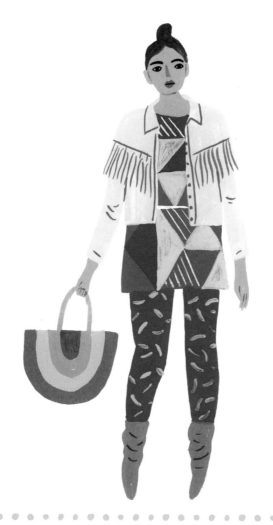

I love looking at fashion magazines for portrait inspiration. Cutting
out a fun sliver of inspiration from a fashion magazine and
pasting it into my sketchbook is a favorite hobby of mine.

Try making a mood board from a piece that speaks to you. Ask yourself
what you like about the image. Is it the color palette, texture, pattern, or
pose? How can you incorporate those elements into your work? I find this
practice to be a great way to loosen up and step back from my paintings.

Now, on to our fashion darling!

STEP 1

With a medium-sized round brush, mix up a peach skin tone. Then paint the woman's head, neck, and hands.

Rinse the brush, and then add her violet shirtdress. Paint just the portion of the dress that is visible.

Add her gray jacket and blue pants.

STEP 2

With reddish-brown paint, add the woman's hair in a top-knot style.

Rinse the brush, and then use coral-colored paint to add an upside-down rainbow near her hand. This will form the base of her purse.

Add a bit of white paint to the coral, and create her slouchy boots.

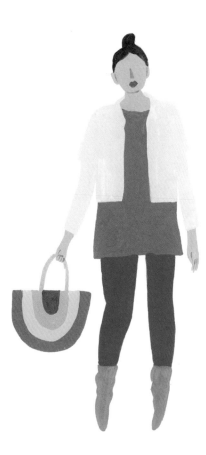

STEP 3

You'll need three colors for this step: taupe, pale pink, and deep red.

Grab your medium-sized round brush and dip it in taupe, forming a point at the end of the brush. Add a triangle-shaped nose to the woman's face. Then paint a handle on her purse and add a stripe to it. Let the paint dry.

Add a pale pink stripe to the purse.

Then use the deep red to paint the woman's lips and the shape in the center of her bag.

STEP 4

With a medium-sized round brush and bright yellow paint, add a 1980s-inspired pattern to the woman's pants.

Then, with a fine-tipped brush and darker taupe-colored paint, add details to her jacket.

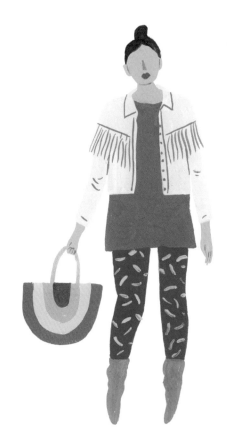

Don't be afraid to get loose with your brushstrokes! It'll add rhythm and movement to your piece.

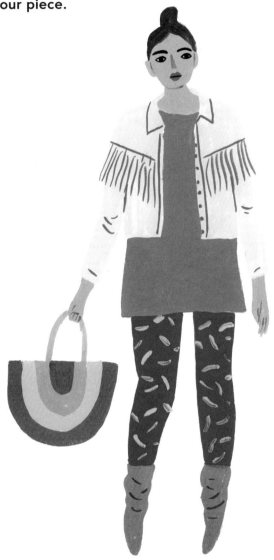

STEP 5

It's time to add the rest of the woman's face! This step is simple, but you have to be careful.

With a fine-tipped brush and black paint, add the woman's eyebrows and her eyes. This is where you'll need to be careful; making a mistake with her pupils can create a wonky-looking portrait, especially if there are no other visible imperfections in the piece.

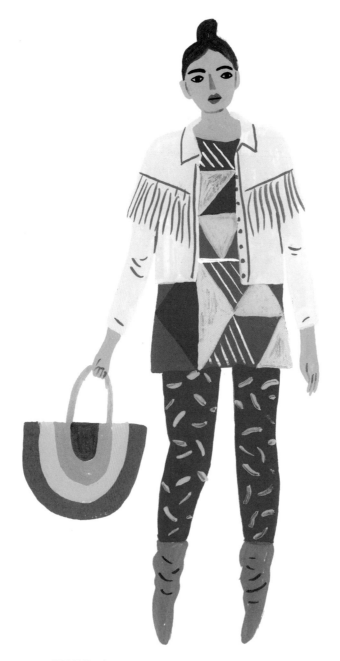

STEP 6

With a medium-sized pointy brush and a deep-blue color, paint shapes on her shirtdress. Let the paint dry.

Then add yellow and mint green shapes to the shirtdress.

Allow the paint to dry, and then add white detailing to her dress.

And now this fashionable woman is runway ready! Great job!

Pattern Library

I like to create image libraries filled with random doodles and ideas. These are useful when I'm working on a composition that needs a pattern or a decorative element and I'm looking for inspiration.

Here are some examples of patterns that might work in a high-fashion portrait.

Try a 1980s-inspired pattern!

This pattern would be gorgeous on a woman's skirt.

Use this as wallpaper or curtains in a fun-loving fashionista's bedroom!

This pattern would make for a stunning shirt…or maybe a headband!

Folk-Art Floral Female

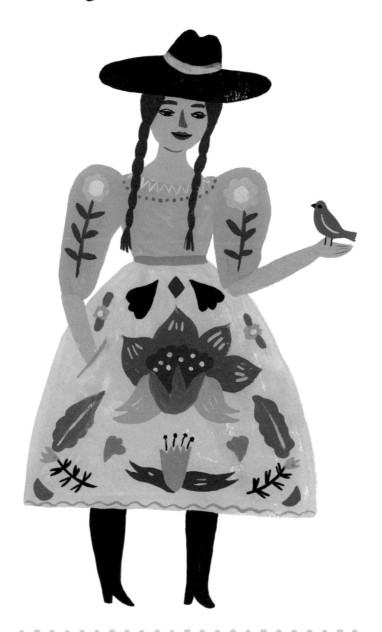

Folk art is one of my favorite genres. Some folk art is very decorative, with floral motifs and intricate designs, while other styles are simpler and more primitive. This piece is a little of both!

STEP 1

Start by mixing a warm sandy skin tone, and then grab your medium-sized round brush to paint the woman's head, neck, and arms.

STEP 2

Use a bright sky blue color to paint the woman's blouse and mustard yellow for her skirt. Save these colors on your palette for painting details later.

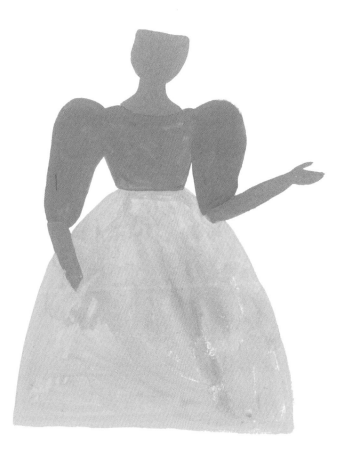

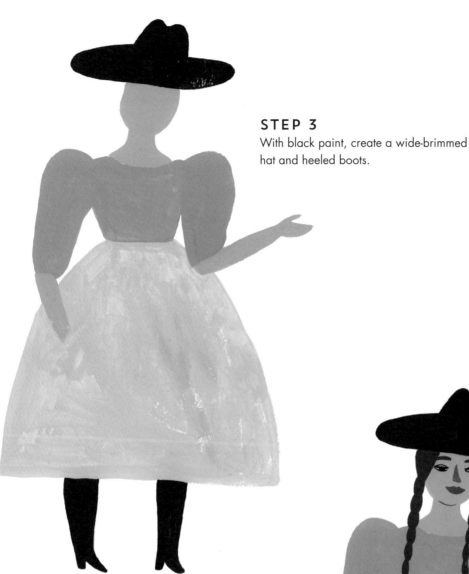

STEP 3

With black paint, create a wide-brimmed hat and heeled boots.

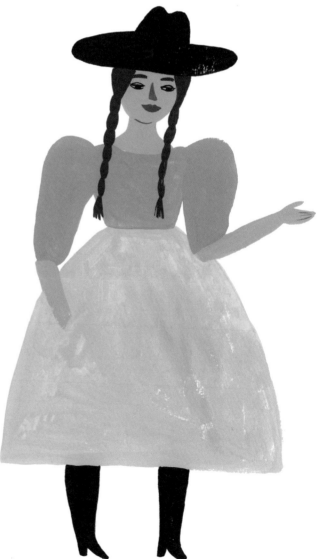

STEP 4

Now let's work on the woman's face and hair.

Start by mixing up a dark brown shade, and use your fine-tipped brush to paint her braids and eyebrows. Mix the same brown shade with the color you used for the woman's skin color plus a touch of magenta, and add her nose. Use magenta for her lips.

Finish up the woman's face by adding her eyes. Use your fine-tipped brush here, and don't rinse it when you're done.

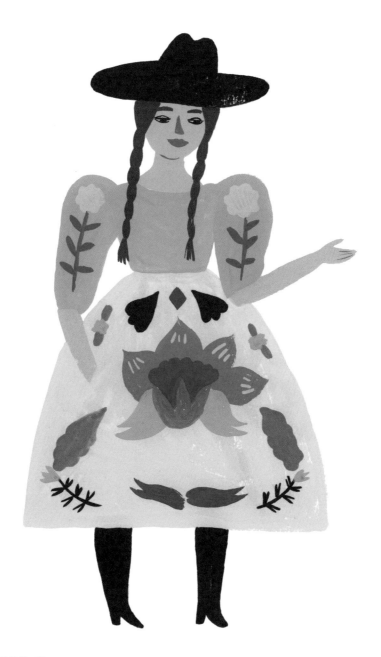

STEP 5

You should still have your fine-tipped brush with black paint on it; grab that, and add stems and leaves on the woman's skirt as well as the two shapes at the top of it.

Then use your medium-sized round brush and magenta paint to add big flower petals in the center of her skirt.

Next, use a deep blue color and your medium-sized round brush to paint the stems on the sleeves, the center of the magenta flower, and shapes at the bottom of her skirt.

Then use deep green to add more details on her skirt, and use pale pink for the flowers on her sleeves and details on the magenta flower.

Now use the sky blue color of her shirt to add buds and shapes to the skirt.

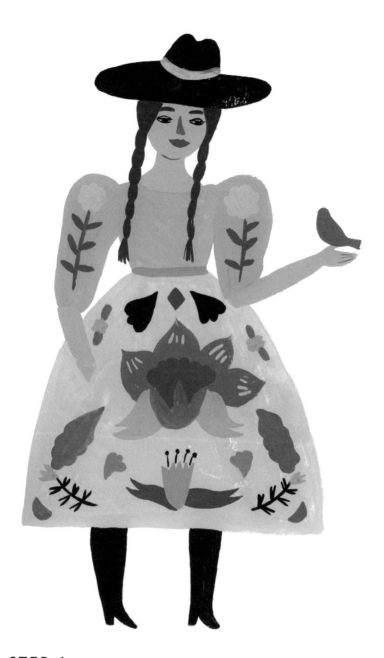

STEP 6

Use light gray to add the band on her hat, and use pink for the band around her waist and the tulip-like flower on her skirt.

Add a green bird in her hand and black anthers (the part that contains pollen) to the tulip-like flower.

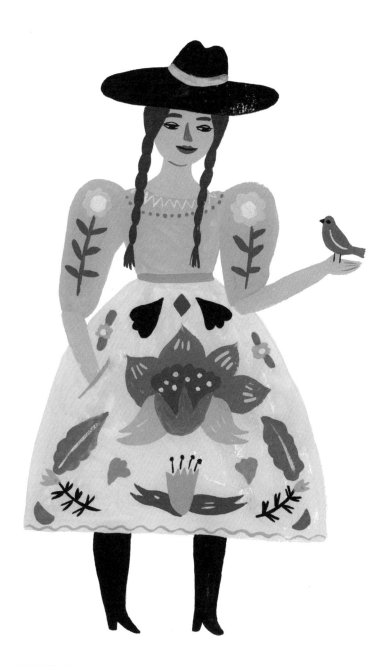

STEP 7

Using mustard yellow color again, add detailing around the woman's collar, centers to the flowers on her sleeves, and a wing on the bird. Then add yellow dots and lines on the deep blue shapes.

Use black to create the bird's beak, eye, and legs, as well as the crease in the woman's lips. Add dots near the zigzag lines on her collar, and you're all done!

'80s Girl

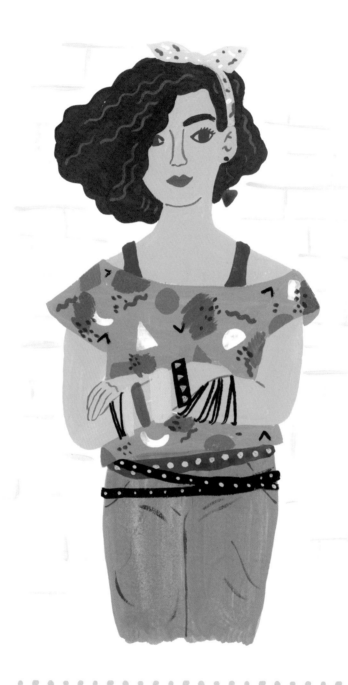

Fashion during the 1980s was bold, colorful, and over-the-top, and it's an aesthetic that's really fun to capture. Let the geometric pattern on your subject's shirt take center stage, and create a totally rad-looking girl from the '80s!

STEP 1

Start with a peachy-pink skin tone, and add the girl's head, ears, neck, shoulder area, arms, and hands.

When painting portraits, play around with your subjects' positioning. Here, my 1980s girl has her arms crossed, like she's got some attitude!

STEP 2

Now mix up a bright pink color and paint her top. Then create a
turquoise color, and add her pants.

• • • • • • • • •

**Let the paint dry
between steps to
avoid smearing.**

STEP 3

Let's work on the girl's asymmetrical bob. Use a deep auburn color and your medium-sized round brush to create a curly hairdo worthy of Molly Ringwald.

Leave her hair flat on top; you'll add a headband later.

STEP 4

Use the same auburn color to add the girl's thick eyebrow. (Think Brooke Shields!)

Mix your flesh color into the auburn, and paint lines to define the girl's ears, chin, arms, and hands.

Use electric blue paint to give your subject eyes, complete with 1980s-style eyeliner!

• • • • • • • • •

**Don't forget to
rinse your brush
between colors!**

STEP 5

It's time to accessorize your girl! Using the same electric blue paint
from step 4, add tank-top straps to her shoulder area. Then mix up
some blue-gray paint to add a headband and bracelets. Combine the
blue-gray with the turquoise paint you used for the girl's pants, and
add another bracelet on her arm.

Let the paint dry, and then paint blue dots on her headband, belts
around her waist, and bracelets on her arm.

Add a pattern to her shirt. I used black, orange, green, and pink to
create circles, triangles, squiggles, and other 1980s-inspired geometric
shapes, but you should feel free to add your own design!

STEP 6

It's the fine details that pull it all together! Add the girl's earrings, and use orange mixed with a touch of hot pink for the highlights in her hair. Add lines and folds in her jeans using dark blue.

Then grab your blue-gray paint, and form some simple brick lines for the background of the painting. Also add studs to her bracelets and belts.

I bet she looks pretty rad now. Nice work!

What's Your Favorite Decade?

Maybe you're not a fan of the 1980s? That's OK!

Are you a '90s baby? Paint a young man or woman wearing a grungy-looking outfit, complete with a baggy flannel shirt. Do you prefer the flapper look from the 1920s? Draw a woman wearing a drop-waist dress, long beaded necklace, and feathers in her hair. You could also go for the 1970s look, with a person wearing bell-bottoms, platform heels, and polyester.

Use the space below to draw or paint a figure from your favorite decade!

Hipster Guy

What's a hipster? You may know a few, or you might even be one!

I would define a hipster as a kind of modern-day beatnik. Many hipsters seem to work in creative professions, and they often buck against the mainstream. While you're at the office, your favorite hipster is probably listening to a band you've never heard of or scoring a shirt at an obscure thrift store that's only open on Tuesdays from 1:45 to 2:30 p.m.

The point is that hipsters are fun to paint because they often have a great sense of style!

STEP 1

Use black gouache and a medium-sized brush to paint the man's hair, mustache, and beard.

Apply just enough paint to the brush so that you can create points in his hair. Then, as you move down to the rest of his hair, mix a bit of water into the black paint so it isn't completely opaque. This will create nice values and tones.

Then paint the man's beard, finishing it off with his mustache. Work around the shape of his face, and leave space for his lips.

STEP 2

Grab a fine-tipped brush, and load it with a bit of black to paint the man's ears, neck, shirt, and arms. Keeping the brush somewhat dry and the tip pointed will create an expressive, textured line quality.

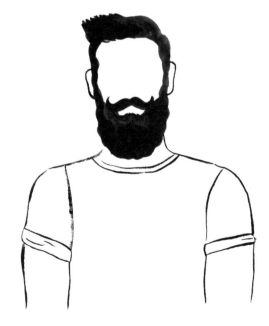

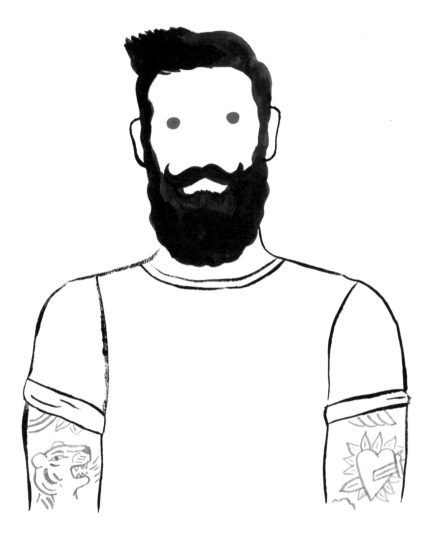

STEP 3

With bright blue paint and a fine-tipped brush, add the man's eyes.
(Don't worry if he looks a bit creepy right now; you'll fix the eyes later.)

Then add tattoos to both of his arms below the shirtsleeves.

I've chosen to tattoo my hipster with doodles and a tiger head on his left arm and wings and a sacred heart on the right one. What are your favorite tattoo designs?

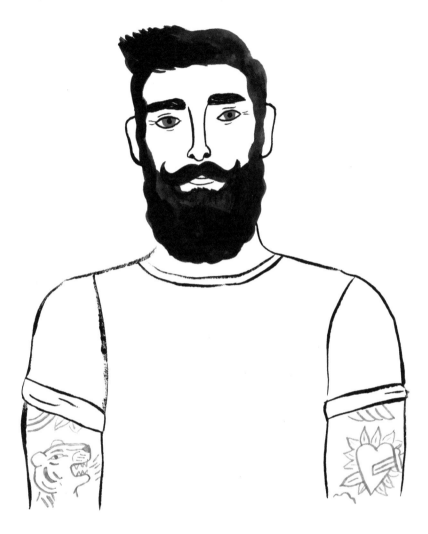

STEP 4

Let's do the line work for the man's face. With a fine-tipped brush and a small amount of black gouache, use generous brushstrokes to create his eyebrows, and then add his eyes and crow's-feet. Don't forget the pupils!

Then paint the man's nose and lips. Hello there, handsome!

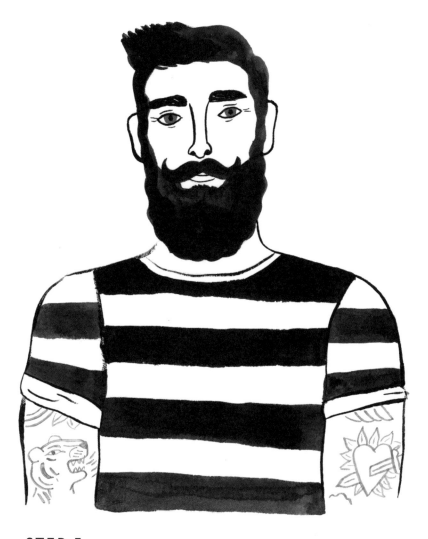

STEP 5

Now, for the fun part: Let's add stripes to the man's shirt!

You want to create tonal variety here. Create your first brushstroke in the center section of his shirt, starting at the neckline. Then move down to add more stripes.

Load a large brush with a mix of black gouache and water. Next, paint stripes on each of his sleeves. The stripes don't need to line up exactly.

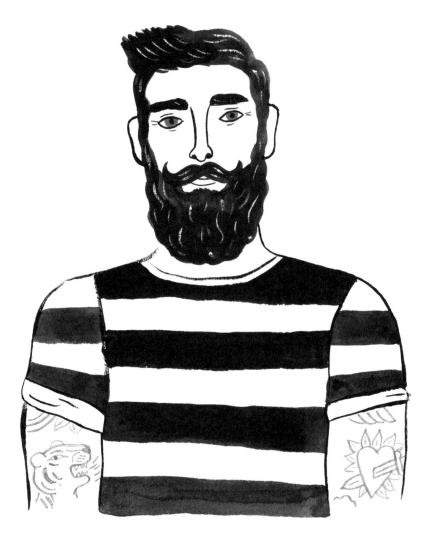

STEP 6

You're almost done now, but first this hipster needs a bit of detail in his hair.

Use white paint and a fine-tipped brush without much water on it; you want texture in your lines. Following the natural shape of his hair, stroke fine, curving lines on his head and within his beard and mustache.

Unexpected Color Combinations

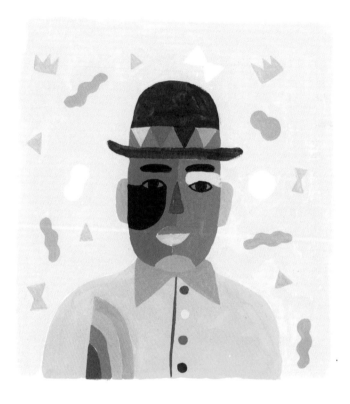

Abstract paintings are more difficult than they look, but in my opinion, abstract portraits in particular are easier to do. At the very least, you have the framework of the human form to use as a loose guideline.

Your subject needs a head and eyes…maybe a mouth (or maybe not!). The fun really begins when you deconstruct what that person looks like and start adding unique features that both capture your subject's appearance and make him or her look abstract at the same time.

Let's get started!

STEP 1

With a medium-sized round brush and navy-blue paint, create a half-circle for the man's hat. Leave space underneath for the hat band, and then add a line for the brim that turns upward at the ends.

STEP 2

Rinse the brush and mix up a light violet color. Paint a shape for the right side of the man's face, leaving the nose and mouth cut out.

Then use mustard yellow to form the shape of the man's shoulders and chest, with a shark fin-like shape cut into the bottom-left corner, as shown above. Add a triangle to the hat band as well as the man's bottom lip.

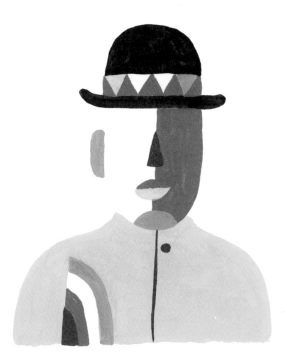

STEP 3

You'll add lots of color in this step!

Grab your medium-sized round brush and red paint, and add the man's nose, a line on his shirt, a button, and the bottom part of the rainbow on the left.

Rinse the brush and add coral-colored triangles to his hat band. Also fill in his top lip and add a stripe in the rainbow. Let the paint dry.

Rinse the brush again and load it with light blue paint. Add a triangle to the man's hat band, paint his left ear and chin, and add a blue stripe in the rainbow.

STEP 4

Grab a deep blue paint color. Add a triangle to the man's hat band, and then fill in the other half of his face. Add a button to his shirt. I love how the colors pop here!

With pinkish taupe, add the man's right ear and another stripe in the rainbow.

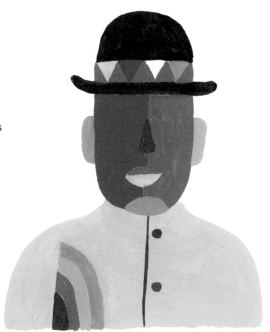

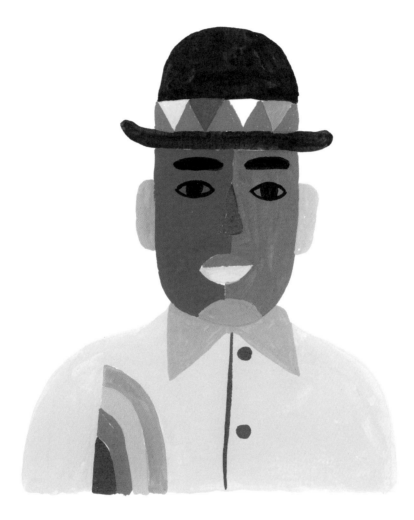

STEP 5

It's time to add the eyes! Using the same navy blue you used for the man's hat, paint his thick eyebrows and soulful eyes.

Rinse the brush, mix mustard yellow into a bit of blue, and add the man's shirt collar.

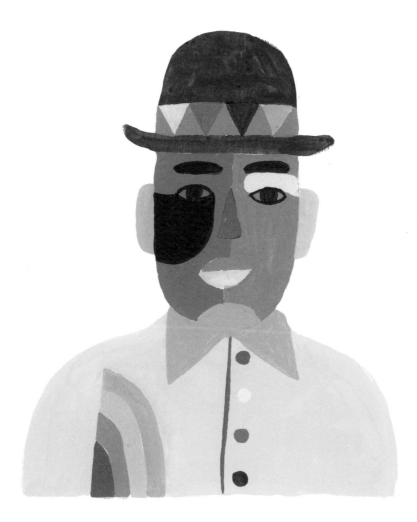

STEP 6

With wine red paint, add the patch of color under the eye at left.
Fill in the remaining triangle on his hat band and add a button to
his shirt.

Then use mint green to create a shape above the eye at right as
well as the last button on his shirt.

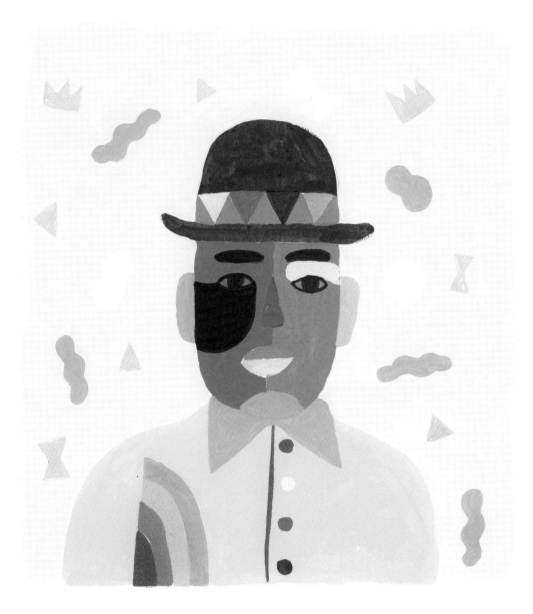

STEP 7

Use a large brush and mint green paint to fill in the background. Let the paint dry.

With smaller brushes and white, bright blue, and taupe paints, add the shapes in the background.

Now your abstract portrait features a spectrum of colors, shapes, and fun. Well-done!

Girl with Flowers in Her Hair

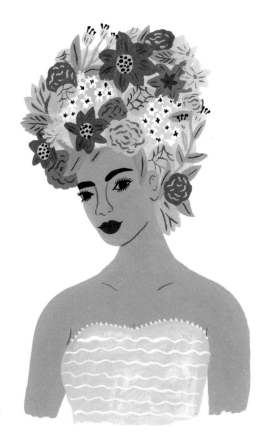

This portrait is inspired by haute-couture fashion and 1950s-'60s bathing beauties.

I love painting flowers because they can be portrayed as exotic and strange or classic and calm. Another thing I enjoy about painting flowers is that they can be painted from real life or totally made up, and there are so many shapes and sizes to paint and draw. Also, depending on your preference, you might want to use all the colors in your palette, or just a few.

Let's get started!

STEP 1

Mix up the woman's skin tone, and with your medium-sized round brush, paint her face and ear. Then work your way down to her arms. Leave negative space for the top of the woman's dress.

STEP 2

Now mix a bright neon-green color, and then paint the mossy underlayer of the woman's hair. This will form the base, so you don't have to fill every space with flowers. Let the paint dry completely.

STEP 3

With your medium-sized round brush and dark green paint, drop in leaves and stems over the moss.

Use a large brush and blue-gray paint to form the top of the woman's dress.

Use a fine-tipped brush for the bunches of small white flowers. Move around the woman's head, letting the paint dry between colors.

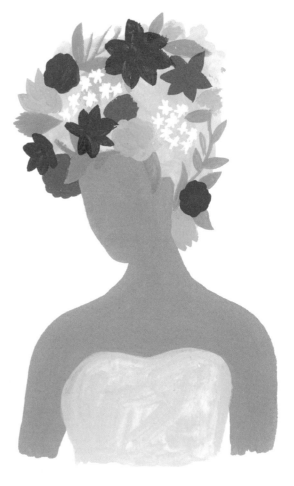

STEP 4

Now for the fun part! Add flowers on top of the moss and leaves using pale pink, white, deep blue, coral-orange, and magenta paint colors.

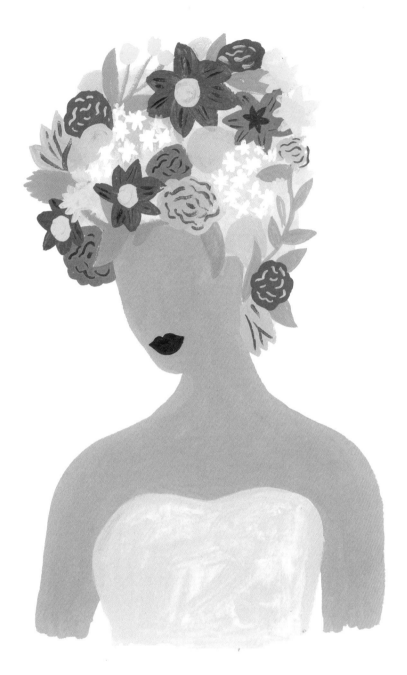

STEP 5

Add the large blue-gray flowers. Then, using magenta, add the details on the pink flowers. Use blue-gray for the details on the dark blue flowers, and wine red for the detailing on the orange flowers. Use this color for the woman's lips as well.

STEP 6

Use a fine-tipped brush and black paint to add the woman's thick eyebrows. Then paint her eyes, eyelashes, and the line between her lips.

It may be best to use another brush for this next step, or rinse the same brush well. With white paint, add the detailing on her dress.

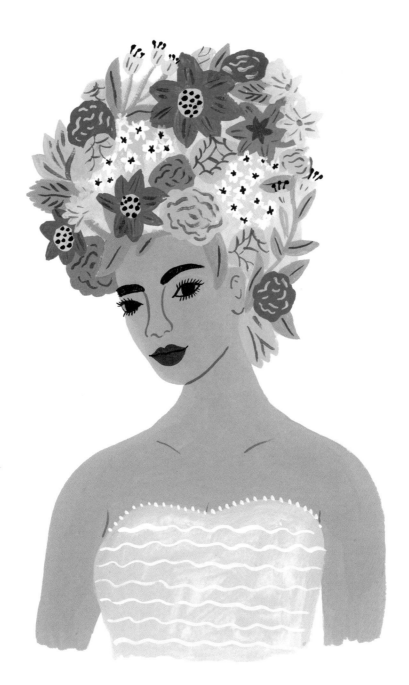

STEP 7

With your fine-tipped brush and black paint, fill in the final details on the flowers on the woman's head.

Stunning! You've done a phenomenal job!

Flower Library

I created this image library of flowers to use as inspiration in my next floral-full portrait. Which is your favorite? Which flowers would you add to your own image library?

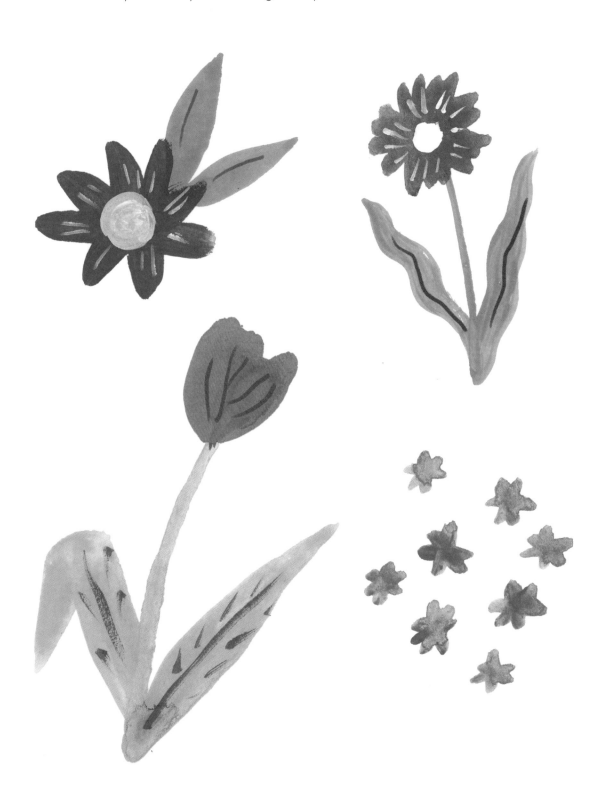

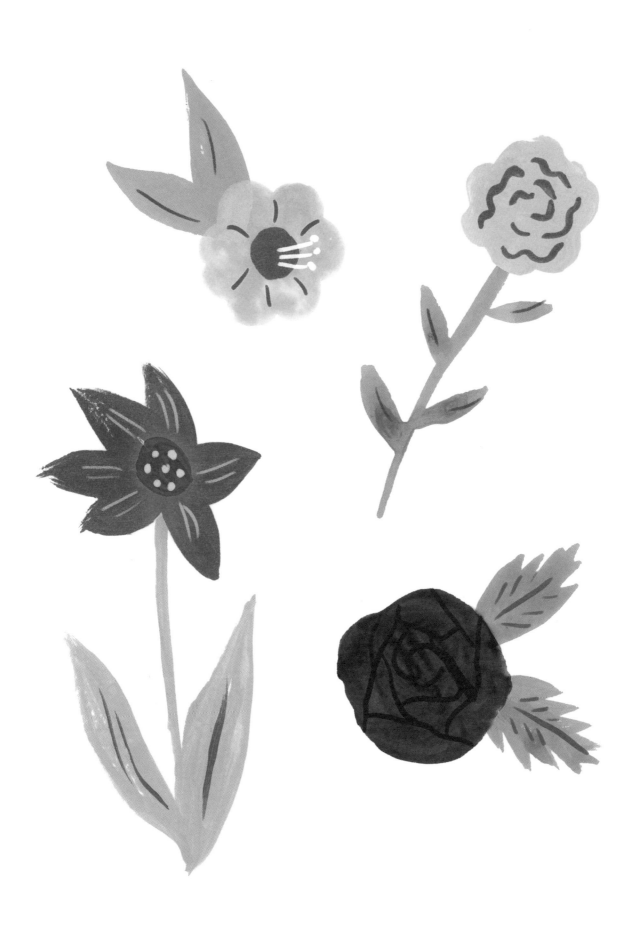

Victorian Couple

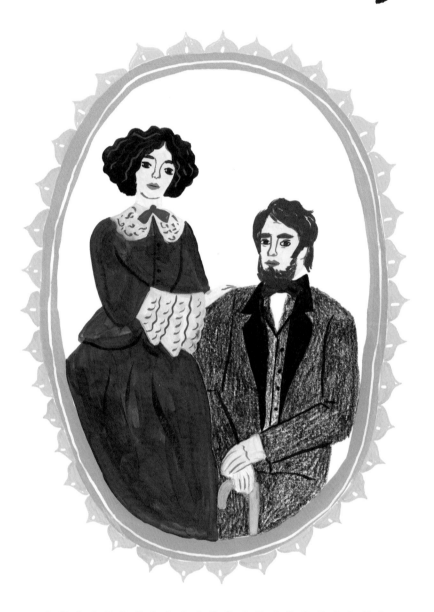

One of my favorite pastimes is looking at old family photos on Pinterest, in antique shops, or, if I'm lucky, at a friend's home. Because they're all in black and white, I sometimes wonder what colors the clothing might have been.

In this project, you'll paint a couple from the Victorian era. Since you're creating your own figures, you may as well add a little color!

STEP 1

With the point of your medium-sized round brush and mustard yellow paint, form a large oval.

Add another dollop of mustard yellow to your palette, mix in a bit of white, and make pointed scallops all the way around the oval.

Use a medium-sized round brush to add another mustard yellow oval within your first one, making sure to cover any uneven paint from the scallops.

Allow this to dry, and then use white paint to form a line inside the oval and add details to the scallops.

STEP 2

With your clean medium-sized brush, use bright red-violet paint to add the shape of the woman's dress inside the oval frame. Reserve this paint on your palette.

STEP 3

With a bright blue colored pencil, fill in the man's clothing, including his tie, leaving negative spaces for his hands, collar, and cane.

Then go over the blue with a black colored pencil.

Notice how the blue shows through the black, creating a rich effect.

STEP 4

With a medium-sized round brush and pale peach paint, add the couple's faces and hands.

Let the paint dry. Then add a black, wavy bob to the woman's head, and paint the man's collar and suit details.

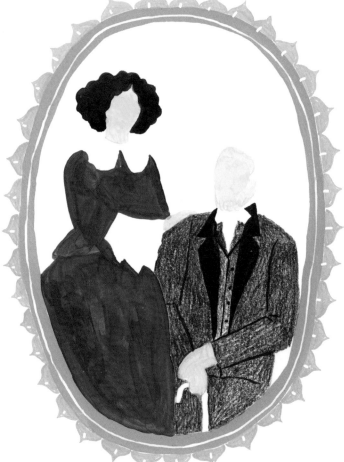

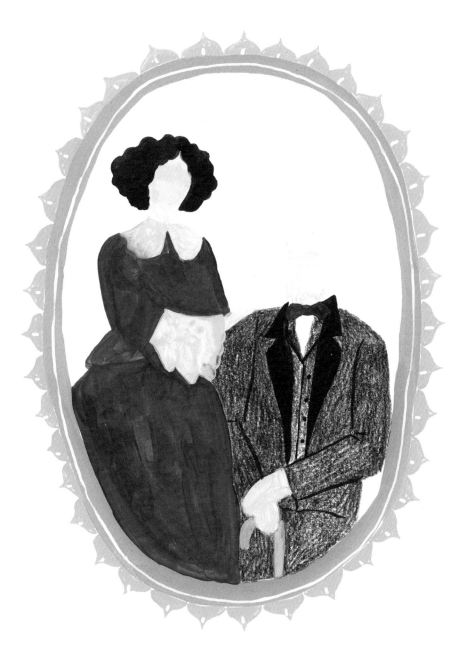

STEP 5

Use blue-gray paint to add the woman's collar and cuffs and the man's cane.

With a fine-tipped brush and red-violet paint, form the man's bowtie.

Now this Victorian man looks dapper, but he needs a face and some hair!

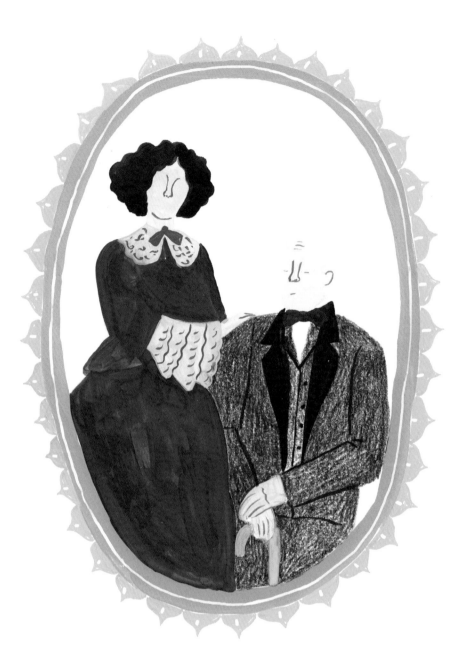

STEP 6

Add a touch of brown paint to your peach skin tone, and add the couple's facial features. Don't forget their hands!

With bright blue paint, add the bow to the woman's collar as well as some lace detailing on her collar and cuff. Also add a few hints of blue to the man's bowtie.

Lace is difficult to illustrate, so keep it suggestive— don't worry about including every detail!

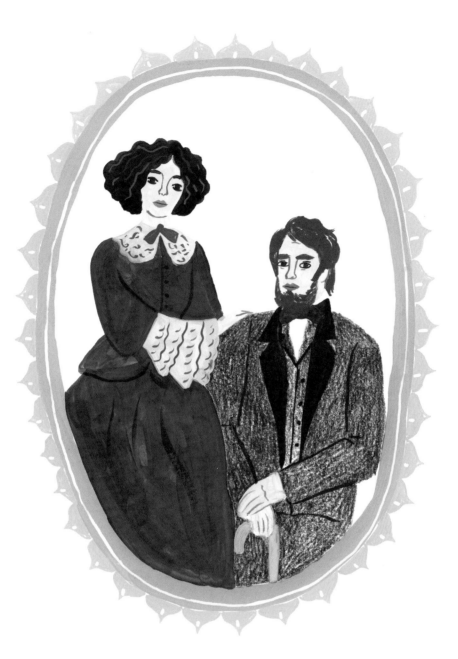

STEP 7

Now develop the couple's eyes and lips, along with the gentleman's coif.

Add touches of blue and black to the red-violet paint on your palette to form a deep, dark purple. Give the woman eyebrows and eyes. Then move over to the gentleman and add his eyes.

Grab a bigger brush and some red-brown paint, and add the man's hair, beard, and eyebrows. Use loose strokes to create an expressive effect.

When you see portraits from the Victorian era, the subjects usually aren't smiling, but your figures still need lips! Using a fine-tipped brush, add the couple's lips. Mix in a bit of purple, and then add lines to separate their lips and finish up your old-fashioned portrait!

Swing-Dancing Couple

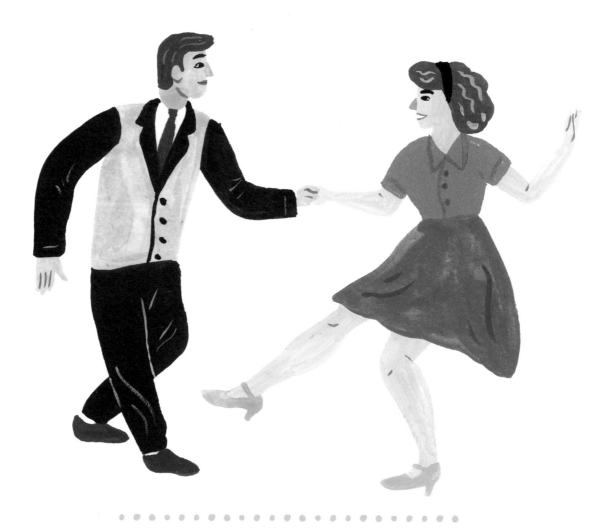

Swing became popular during the 1920s as a form of jazz music that evolved into a word used to describe a certain style of dancing. There are many types of swing dances, including the Lindy Hop and the Charleston, and these remain popular throughout the world even today.

Painting this swing-dancing couple gives you a chance to practice capturing movement.

STEP 1

Lightly pencil in the couple to give yourself a guideline from which to work.

Then, using a tan color, paint the man's face and hands.

With a peach color, paint the woman's head, arms, and legs.

● ● ● ● ● ● ● ● ●

Without pencil lines, it's difficult to correctly align the couple.

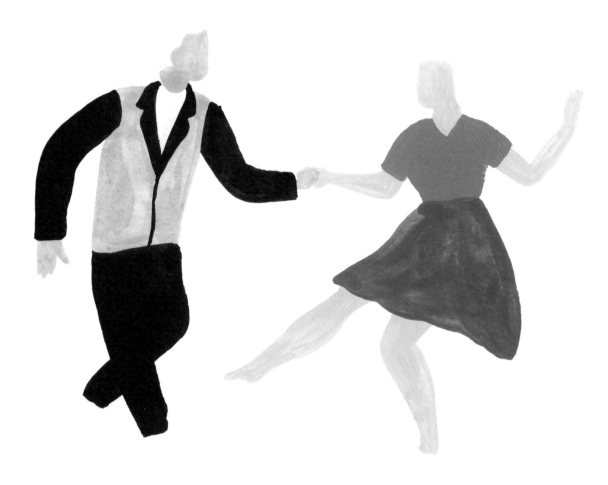

STEP 2

Paint the man's jacket light gray, and then use black to paint his collar, sleeves, and pants.

Rinse your brush thoroughly, and paint the woman's shirt coral. Use blue for her skirt.

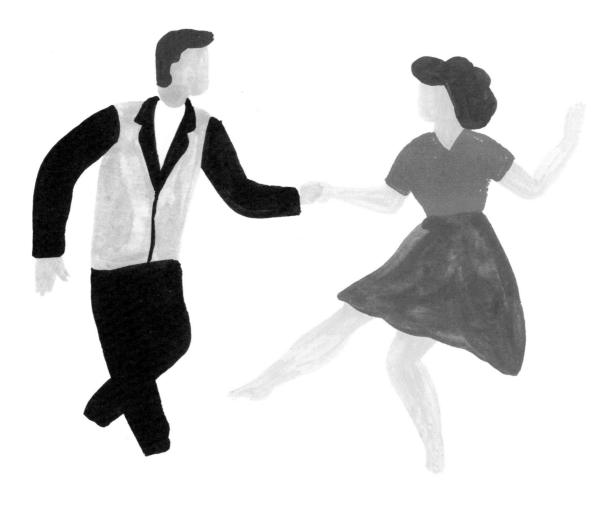

STEP 3

Let's add hair! Use a medium-sized brush to paint the man's hair brown and the woman's hair reddish-brown.

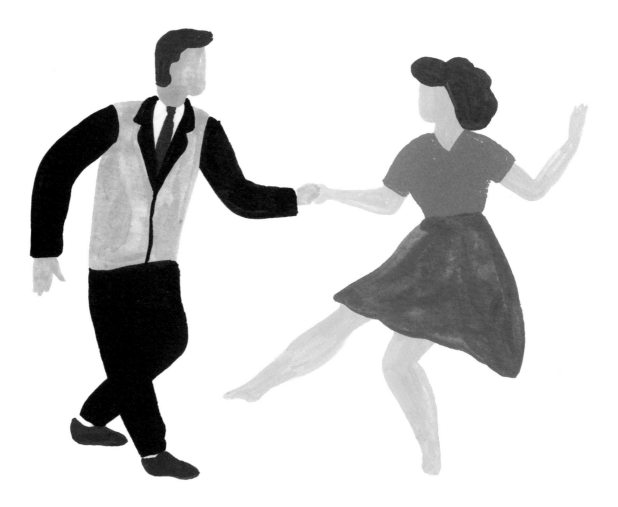

STEP 4

Give your man some swing in his step! With a fine-tipped brush, paint his skinny tie a wine red color. Rinse the brush and paint his blue suede shoes.

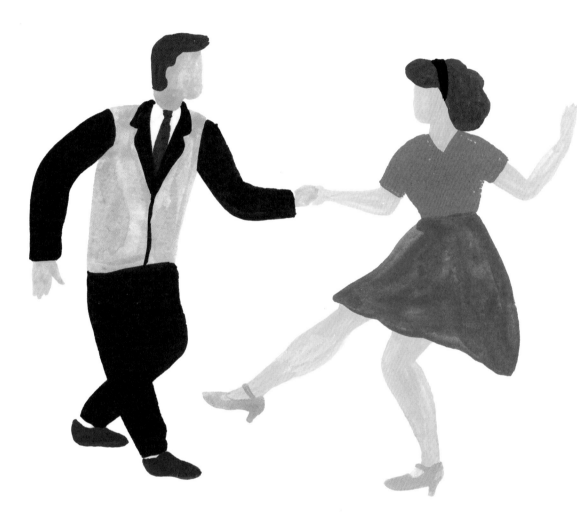

STEP 5

Now add details to the woman. Mix up a mustard gold color using yellow plus a bit of black. Use this to paint her shoes.

Then, with a fine-tipped brush, give the woman a velvety-looking black headband.

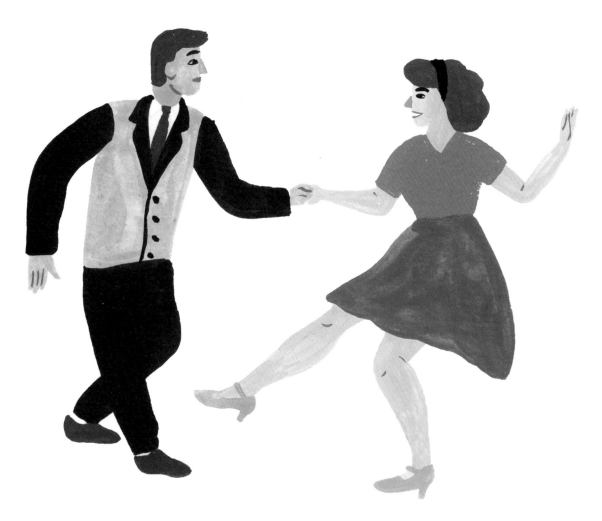

STEP 6

Use a fine-tipped brush and black paint to form the man's eyebrows, eyes, and jacket buttons. Also add the woman's eyes and eyebrows.

Rinse the brush well, and use dark brown paint to create the couple's noses and line details, including their hands and lips.

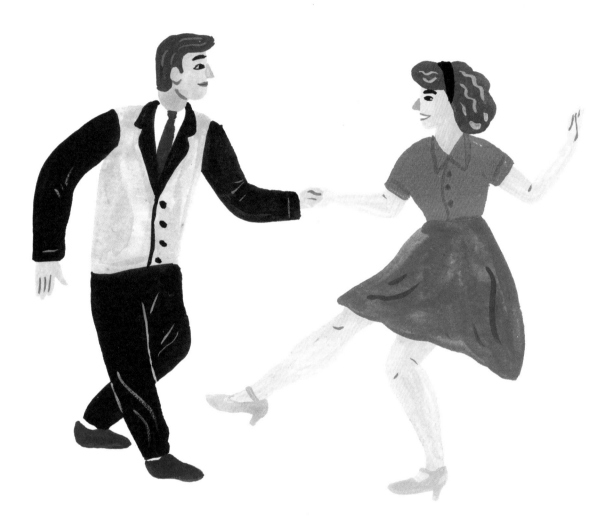

STEP 7

Let's pull it all together with a bit of line work.

Using white paint and a fine-tipped brush, create some strokes in the man's hair. Then move down to his sleeves and pants.

Mix a bit of red-brown paint into the white, and add wavy lines to the woman's hair. Then add dark blue lines on her skirt to imply movement and to finish up your portrait.

Edgar Allan Poe

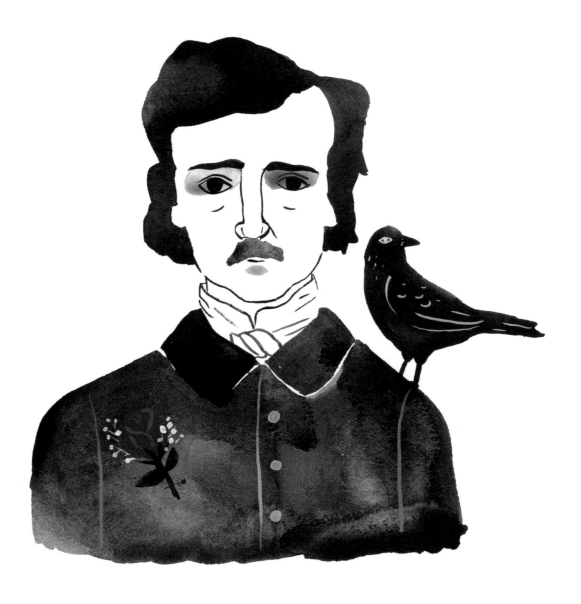

American writer, poet, critic, and editor Edgar Allan Poe became known for his macabre stories and poems, including "The Raven." What better way to capture him than with a mysterious portrait consisting mostly of black and white with a single blood-red rose for an unsettling pop of color?

Notice the variations in value that add interest to the hair. If you don't see these in your artwork, your paint application might be too thick.

STEP 1

Edgar Allan Poe's hairstyle and hairline are distinctive, so let's start with those. Wet your brush with water and dip it in black gouache. Use a round brush to create the shape of Poe's hair, starting with the top left portion and working your way down. (If you're left-handed, begin with the right portion.)

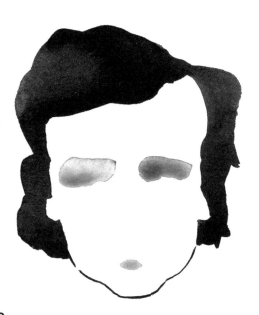

STEP 2

Add more water to the same brush, and paint gray blobs to create sunken-looking eye sockets, which are another trademark feature of Poe's. Although we're working in a graphic manner, the fluid-looking eyes give his face depth and hint at his personality.

With a fine-tipped brush, create a thin, dark line for his jaw and chin.

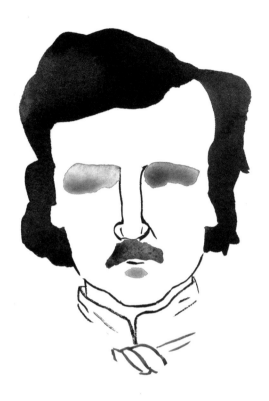

STEP 3

Apply a small amount of black paint to a fine-tipped brush. Don't add too much! Create some test marks on a sheet of scratch paper to ensure you have the right consistency.

Add Poe's nose. Then paint lines for his neck and scarf. It's OK if your brush dries out as you stroke; that will make for a nice texture.

Again grab your big, round brush and some watered-down gouache, and dab on his mustache.

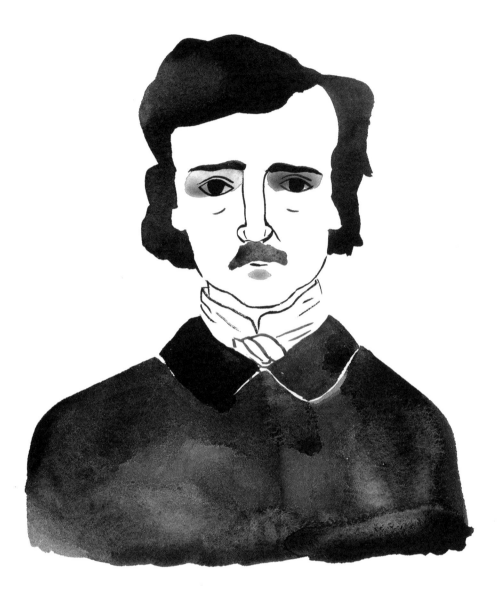

STEP 4

It's time to add Edgar's coat! Wet a large brush, and dip it in black gouache. Just below his scarf, make two round-edged rectangular shapes on either side of his neck for the collar.

Let the paint dry briefly. Then dip a wet brush in more paint and fill in the coat, allowing the overall values to vary for a mottled texture.

Use thin strokes of white to separate the collar from the rest of the coat.

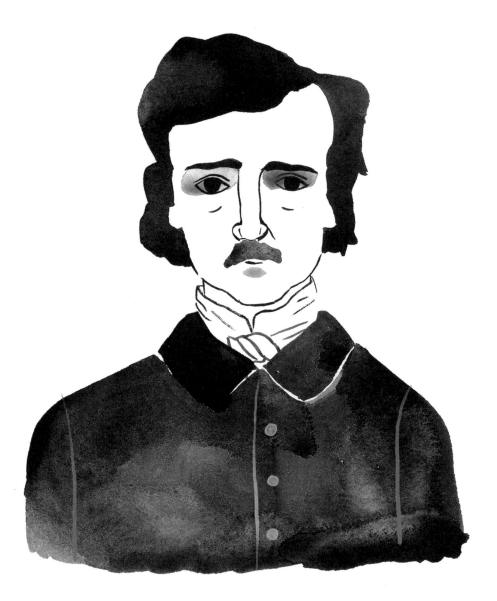

STEP 5

Let the coat dry, and then create gray paint from a combination of the black and white paints you already have on your palette. Using your fine-tipped brush, make a line from Poe's collar all the way down to the bottom edge of his coat. Then create gray lines to define his sleeves.

Next, grab a medium-sized round brush, and use some scratch paper to experiment with creating nice, round shapes. Then create buttons on the coat.

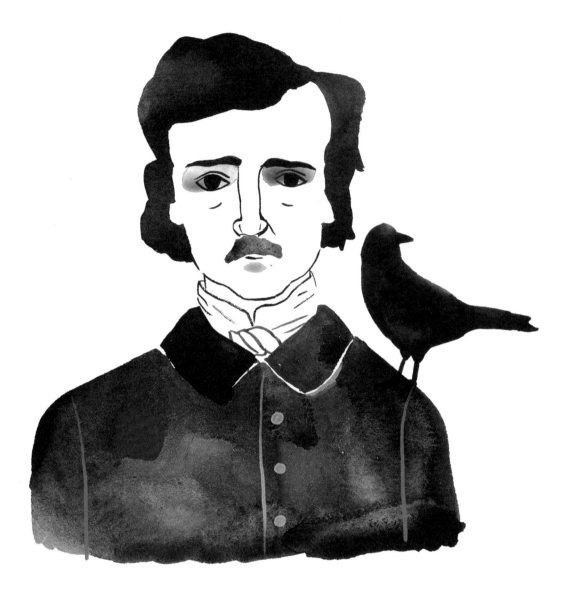

STEP 6

Let's add a raven buddy. Grab your medium-sized round brush and some fresh black gouache. Start by forming the bird's head as a circular blob shape, and then make an oval shape for its body. Next add the tail, legs, feet, and beak.

Then apply a tiny bit of a burgundy paint to your palette. Make sure the paint is opaque and not watery, and add a corsage to Poe's coat. The black underneath should not show through.

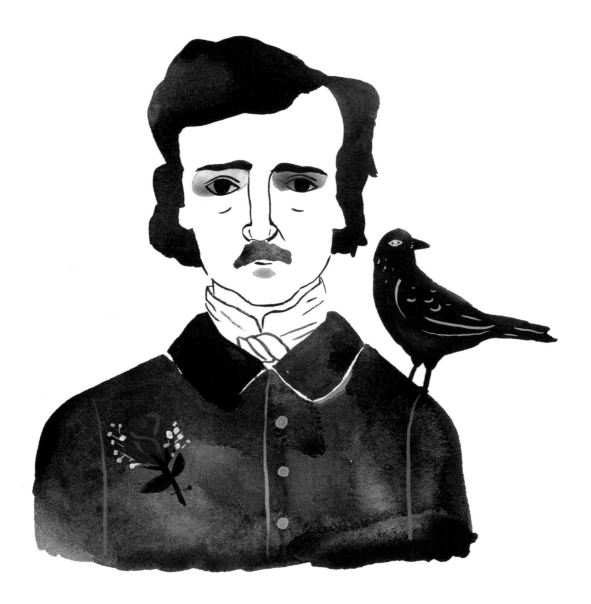

STEP 7

To pull things together, let's add some fine-line touches. With a fine-tipped brush and fresh white paint, give the raven an eye and some feathers. Use the same white paint to add baby's breath in the corsage.

Mix a bit of the burgundy color with white, and add petals to the rose. Rinse the brush, pick up some thick opaque black paint, and create leaves and a stem for the rose as well as a pin to attach it to Poe's coat. Now your Edgar Allan Poe is complete and ready to write some dark but beautiful poetry!

Paint Your Own Poe

Are you familiar with the mystery of Edgar Allan Poe's death? There are several theories on what might have caused it, including alcohol, a beating, disease, and voter fraud. What is known is that a few days before he died on Oct. 7, 1849, Poe was found semiconscious on the streets of Baltimore wearing someone else's clothing. No one knows why! It's said that he was wearing a cheap, ill-fitting suit and a straw hat. What might that outfit have looked like? Try drawing or painting it here!

Woman in a Head Wrap

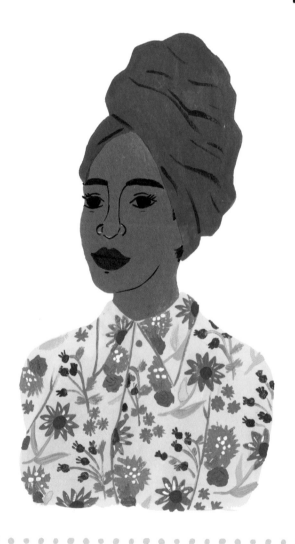

This woman wears her hair pulled back and covered by a bright blue head wrap, which brings out her features and makes her look chic and sophisticated. The head wrap creates a striking pop of color, and her floral-printed shirt has an old-school artsy vibe that's straight out of the 1970s. Let's bring this woman to life!

STEP 1

Using a warm brown paint color and a medium-sized round brush, create the shape of the woman's head. Leave negative spaces for her lips and the head wrap that will cover her hair.

STEP 2

Rinse the brush, and paint the head wrap a bright blue color. Reserve this paint on your palette.

Rinse the brush again and use mustard yellow to paint her shirt.

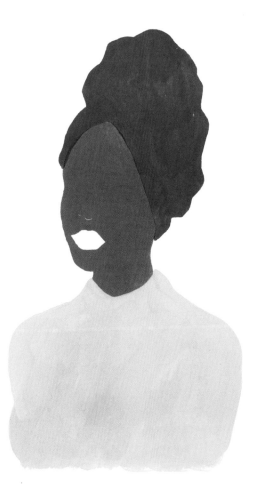

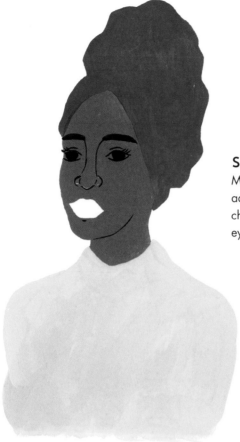

STEP 3

Mix black into a bit of brown paint, and add the woman's eyebrows, eyes, nose, and chin. Make sure you give her long, beautiful eyelashes!

STEP 4

Mix a small amount of black paint into the blue already on your palette, and use a fine-tipped brush to create the line work on the woman's head wrap. Let the tip of the brush dry out a little to create a nice line quality.

Paint the woman's lips using wine red. Reserve this on your palette.

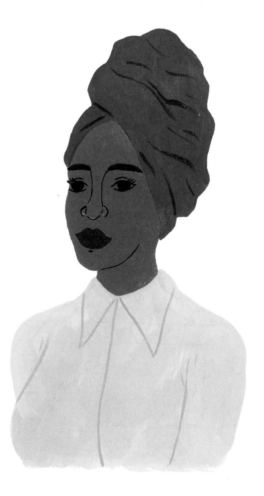

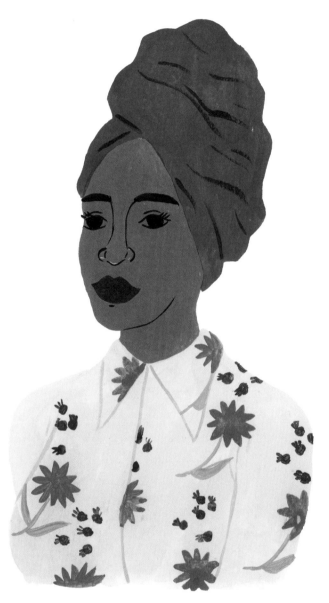

STEP 5

Let's add some flowers! Mix up a soft green color to add the stems and leaves on her shirt.

Then, with the same blue color you used for the woman's head wrap plus a bit of white, add blue buds. Also add plum-colored flowers.

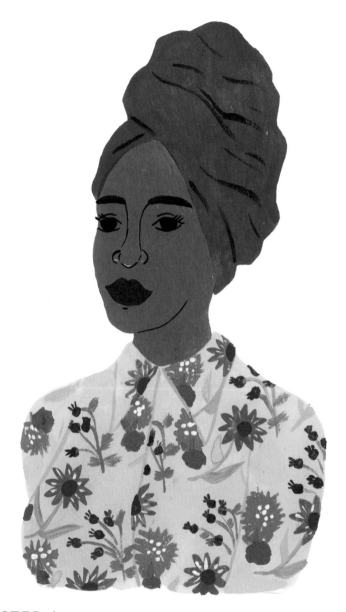

STEP 6

Add more stems and flowers to the woman's shirt using various colors, such as yellow-green, bright pink, and coral. It's OK if these are a little messy and unrefined!

Once the paint is dry, add white detailing using a fine-tipped brush.

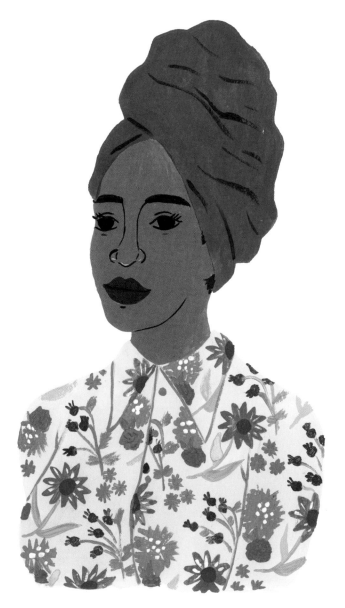

STEP 7

Now for the woman's smile! Mix black into the wine red color you reserved on your palette. Using a fine-tipped brush, make a stroke to separate her lips.

To finish the portrait, rinse the brush well and add more details to her shirt, such as floating pink buds and a collar.

Louis Armstrong

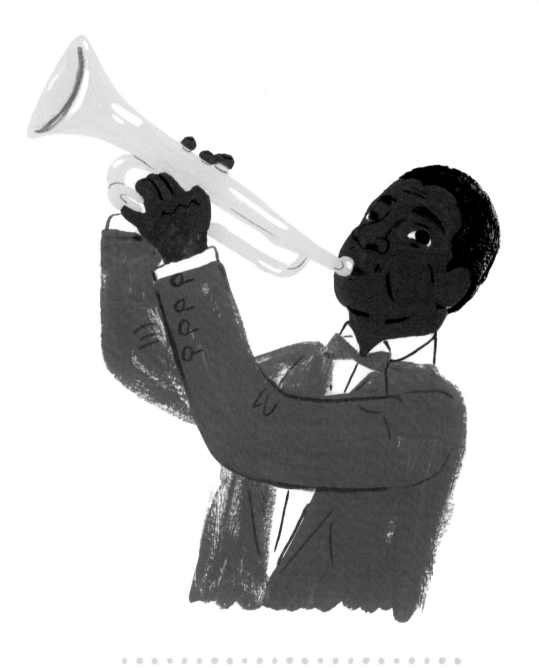

A trifecta of talent, Louis Armstrong was a trumpeter, singer, and composer. Arguably one of the most influential musicians of the twentieth century, Armstrong is known for jazz, but he had a wide impact on music in general. His voice was distinctive and he remains popular today, decades after his death in 1971.

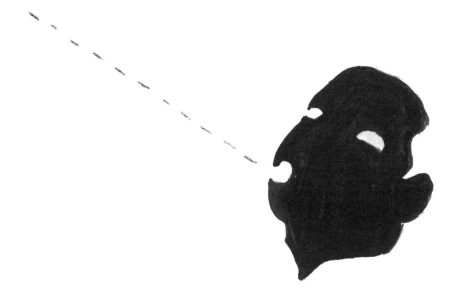

STEP 1

Mix up a color to use for Louis' skin tone. Paint his face, leaving negative spaces for his eyes and the trumpet's mouthpiece, which you will add later.

Use a pencil to draw a dotted line moving diagonally away from his face. This will serve as a guideline for the trumpet.

● ● ● ● ● ● ● ● ● ● ●

Make sure you get the angle of the trumpet line right so that it will match up with your figure's hands and arms.

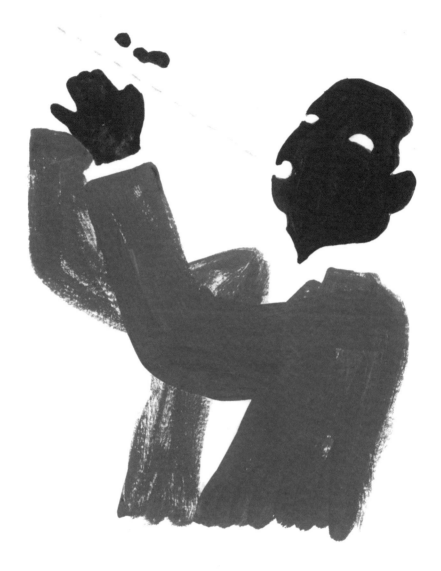

STEP 2

Now paint Louis' fingers. One hand goes on top of the dotted line, and the other goes below it.

Use steel blue paint for his suit, and don't be afraid to let the brush dry out a bit for textured strokes.

This portrait can be loose and improvisational, just like jazz!

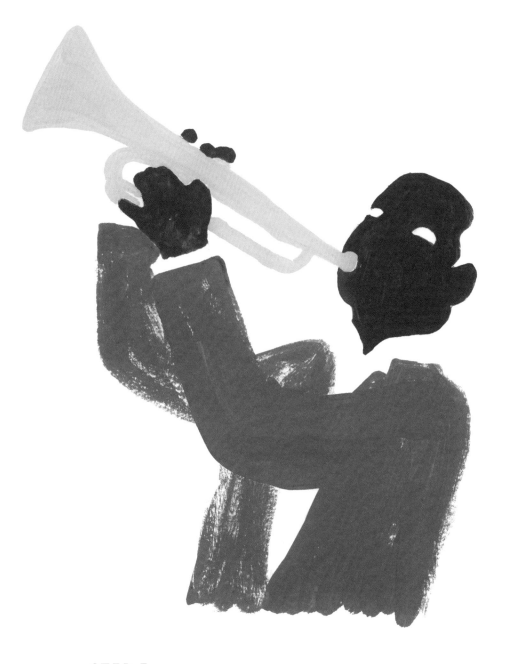

STEP 3

Mix up a mustard yellow color for the trumpet, and with your medium-sized round brush, paint over the dotted line.

● ● ● ● ● ● ● ● ● ●

Make sure the dotted pencil line doesn't show through the yellow paint.

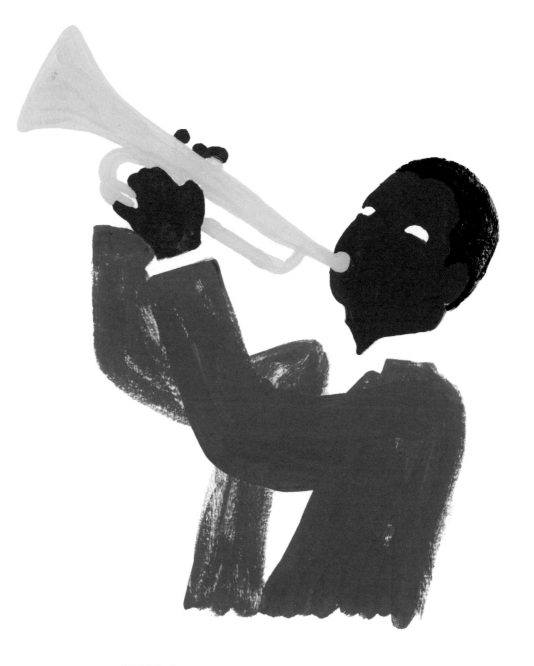

STEP 4

Rinse your brush in water, and pick up some black paint for Louis' hair. Again, let the brush get a little dry; this will create a nice texture in his hair.

● ● ● ● ● ● ● ● ● ● ● ●

Louis Armstrong had a widow's peak, which you will want to include when you paint his hairline.

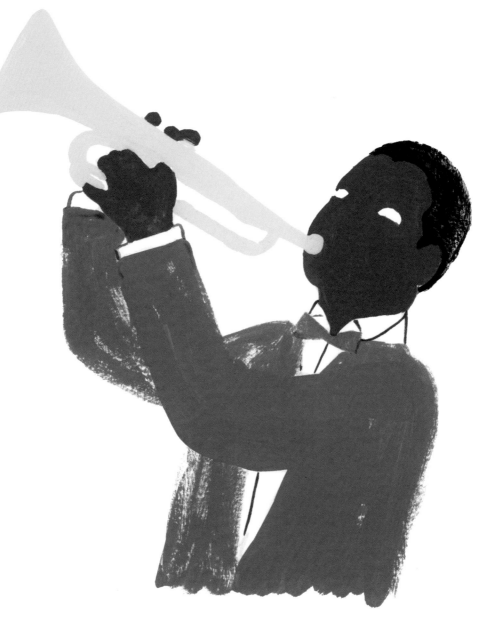

STEP 5

Now grab a red colored pencil and black paint, and let's give Louis a bowtie and details on his shirt, including a collar.

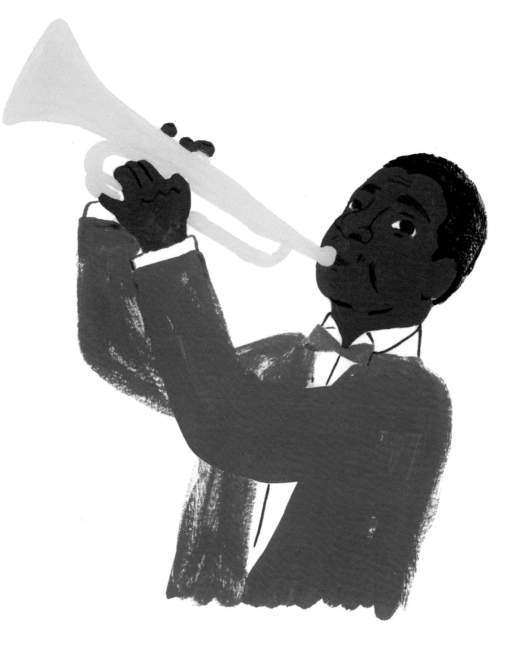

STEP 6

Use a black colored pencil to add Louis' facial features, including his eyebrows, pupils, nose, cheek, and chin.

Also draw in lines for his fingers and knuckles. Draw his lips with a red colored pencil.

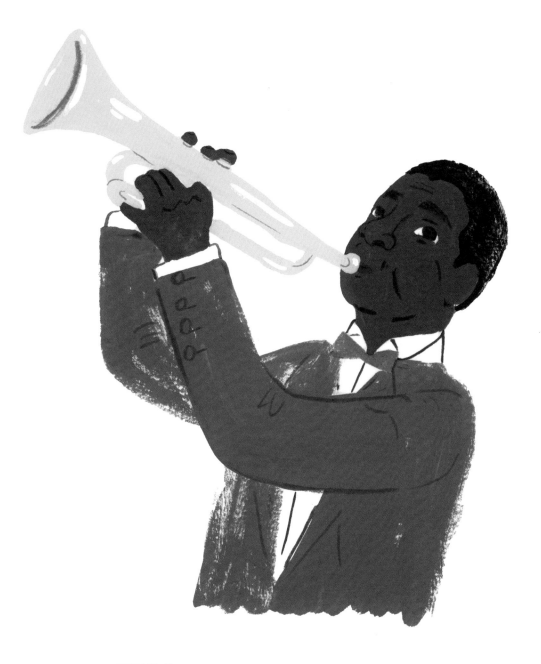

STEP 7

Use a dark blue colored pencil to add detailing on Louis' suit, including buttons on his sleeves. Then use a mustard yellow colored pencil to add realistic-looking details on the trumpet.

Finally, use white paint to give the trumpet some shine and really make it sing!

Ad Man

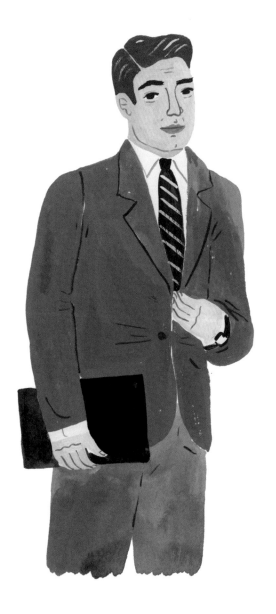

A successful advertising executive from the 1960s could sell anything to anyone, but he had to look the part in order to do so. A sophisticated appearance played a key role: the suit, his clean shave, that watch, a briefcase brimming with ideas… All of these details added to his dapper look and suggested a successful career.

Now, shall we paint our own imaginary ad man?

STEP 1

With a medium-sized round brush, start by painting the man's head, leaving negative spaces for his eyes, eyebrows, and lips. Make a flesh-colored line for the part in his hair.

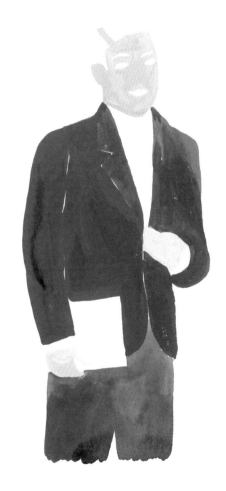

STEP 2

Use a gunmetal gray color to paint the man's jacket. I like to start by creating the collar, and then I make my way down.

Add water to your brush before painting the man's pants.

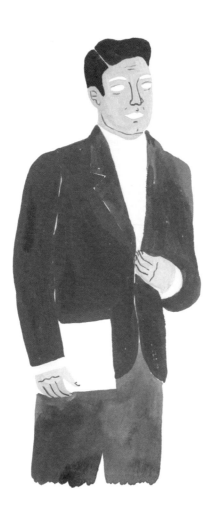

STEP 3

Use brown to paint the man's hair.

Then, with a fine-tipped brush, use the same brown paint to add lines to the man's ears, forehead, under eyes, nose, jaw, and chin. Also, define his fingers.

With a yellow-based cream color, add the shirt and its cuffs.

STEP 4

Use a fine-tipped brush and black paint to add the man's eyebrows. Then move on to his eyes.

With a medium-sized round brush, add the tie and briefcase. Reserve the black paint on your palette.

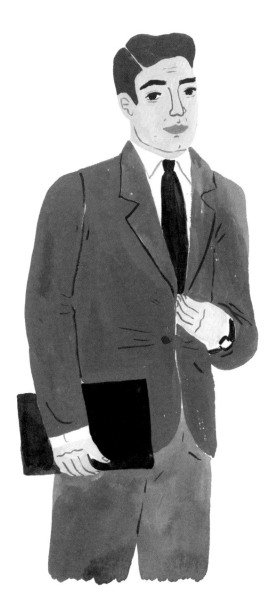

STEP 5

Make your way down to the man's wrist and paint his watch.

Then mix a bit of blue into the black paint, and use a fine-tipped brush to paint lines that define his suit.

Using blue paint, add his shirt collar.

Add his lips with peach-toned pink paint. Reserve this paint on your palette.

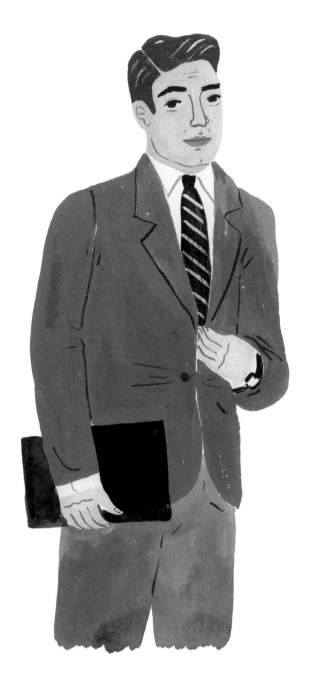

STEP 6

Mix red into the pink paint on your palette and add a smiling crease to the man's lips.

Then paint white lines in his hair to give him a salt-and-pepper look. Add light blue stripes on the man's tie to finish up your portrait.

Add Some Varie-tie

Now that you've painted a more traditional-looking suit and tie, how about personalizing your advertising salesperson? Would you like your ad man to wear a black suit, or maybe a colorful-yet-polished tie? What if your advertising executive were a woman? What might she wear?

Lucille Ball & Desi Arnaz

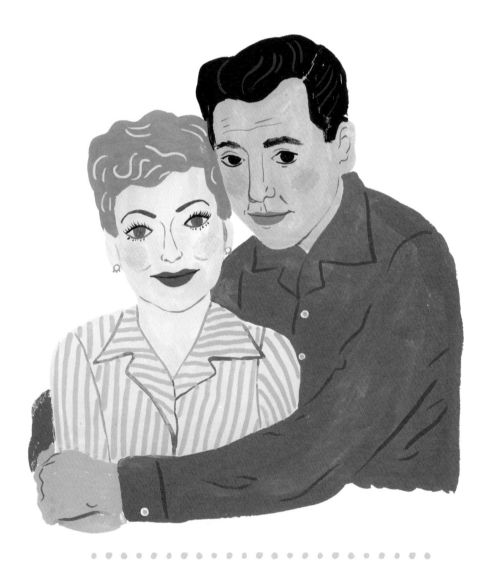

Lucille Ball and Desi Arnaz remain one of television's great love stories. They starred together in *I Love Lucy*, and while their marriage didn't stand the test of time, the public's fascination with them has, and they sure are fun to paint! Make sure to capture Lucille's trademark red hair and Desi's charming half-smile in your portrait of this famous TV couple.

STEP 1

Let's start with skin tone. For Lucy, use flesh color mixed with a bit of white paint. To paint Desi's face, mix up a combination of white water-based gouache and acrylic gouache in ash yellow, flesh, and yellow ochre. Do a few tests to make sure you've mixed up the right value.

Grab a medium-sized round brush, and work from left to right to paint Lucy's face and neck and then Desi's face. (Work from right to left if you're left-handed.) Then add Lucy's bright yellow shirt.

STEP 2

Add that famous hair! Lucy was a redhead, and Desi had very
dark brown hair. For a more dramatic affect, let's go with black.
To create Lucy's hair, I used coral orange mixed with red, yellow,
and white.

Use a well-rinsed, medium-sized round brush to paint both
hairstyles. With a bright red paint color, add Desi's shirt.

STEP 3

Time for stripes! First, use a fine-tipped brush and dark blue paint to outline Lucy's collar. Then add white paint to your dark blue color. Add stripes to her shirt, starting at the collar and making your way around the shirt.

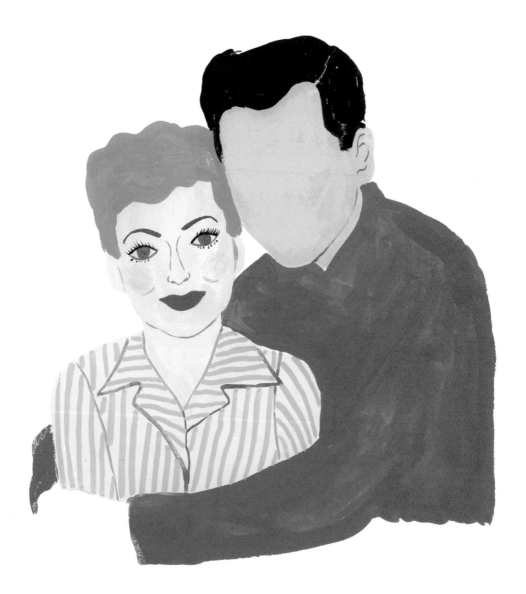

STEP 4

Let's add Lucy's facial features next. Start with her eyebrows, and use a fine-tipped brush and orange-brown paint. Rinse your brush with clean water.

Then move on to her eyes. Outline their basic shape with dark blue paint. With lighter blue and a dry brush, fill in her irises. Let the paint dry, and then use black paint to add her eyelashes. Add a bit of red and/or brown paint to darken the mixture you used for Lucy's skin tone, and paint her nose, cheekbone, and chin line.

Before moving on to step 5, make sure you're happy with Desi's hair. I decided to add a little more flip to the front with black paint.

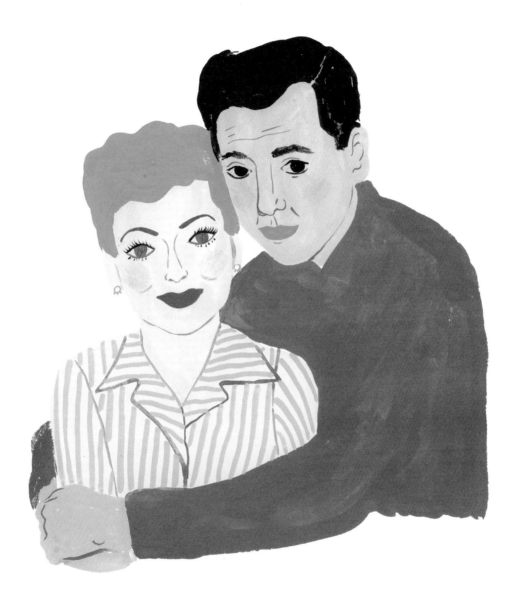

STEP 5

Move on over to Desi! Add his hand using a medium-sized round brush and the same paint color that you used for his face. Then grab your fine-tipped brush and black paint, and add his eyebrows and eyes.

Rinse your brush well, and mix up a little black or brown paint to create a darker shade for his nose, cheekbones, and chin line.

Grab the red paint that you used for Desi's shirt, and add Lucy's famous red lips. Add white and a little bit of sand color to that red paint, and then paint Desi's lips.

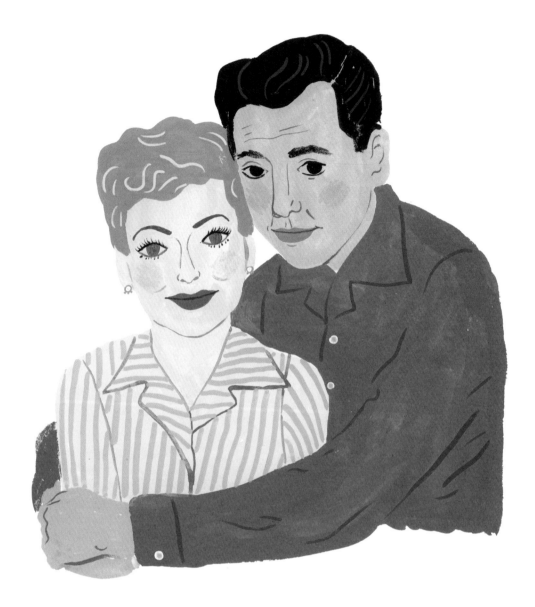

STEP 6

We're almost done! Let's add some detailing to Desi's shirt. Grab your fine-tipped brush again. Mix brown with the red paint you used for Desi's shirt, and add a collar, sleeves, and folds, which should appear soft and cottonlike.

Clean the same brush, mix up a light yellow, and add curls to Lucy's hair.

Desi's hair was curly with a distinctive shape. Clean your fine-tipped brush, and mix up a light blue shade. Use this color to define Desi's slicked-back look.

Now add color to Lucy and Desi's cheeks—pale pink for her and peach for him. Don't press too hard, or you'll have some 'splainin' to do!

Photogenic Couples

What are some of your favorite TV or movie couples? Choose a classic couple, like Lucy and Desi, or a more contemporary one, and paint the famous figures here!

Portrait Gallery

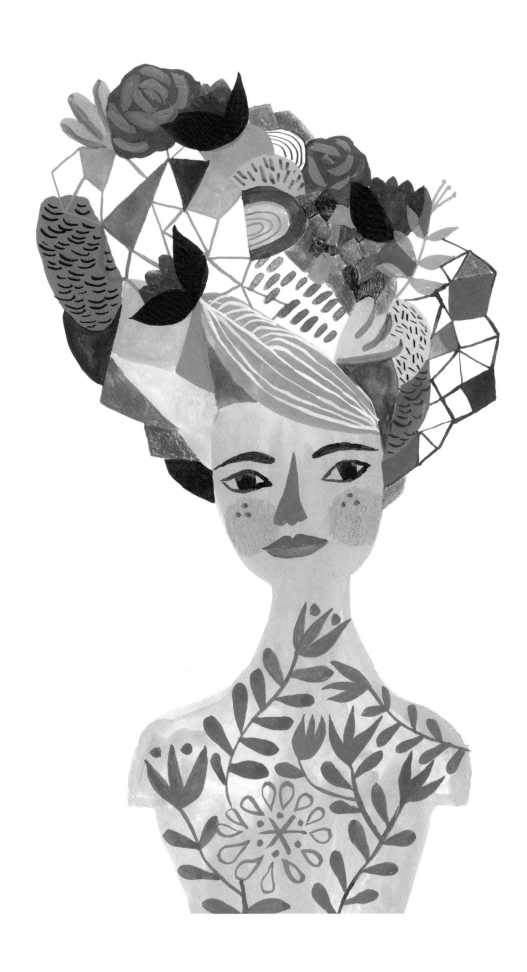

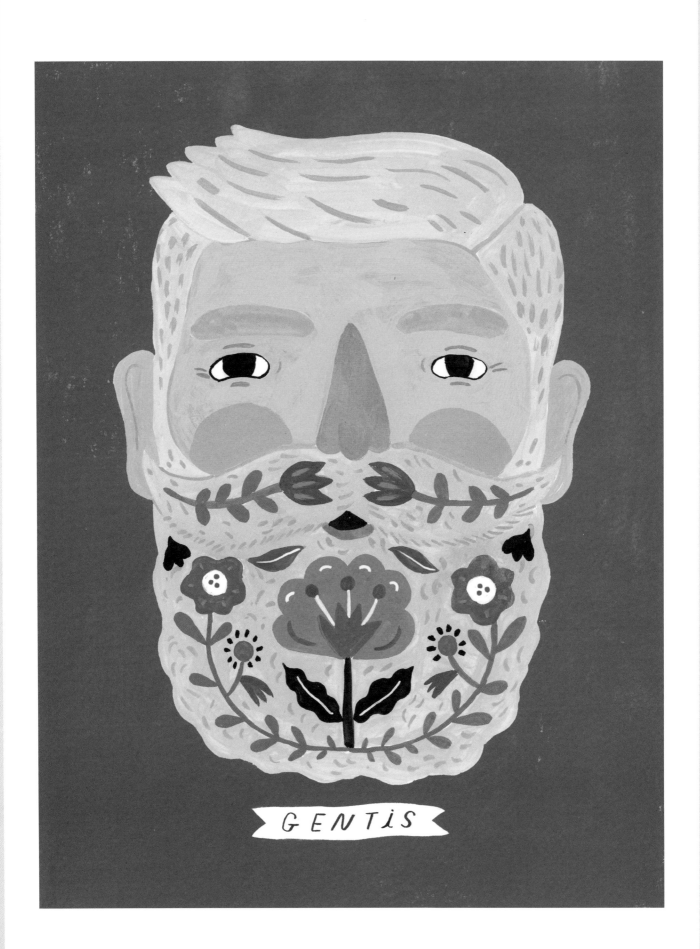

GENTIS

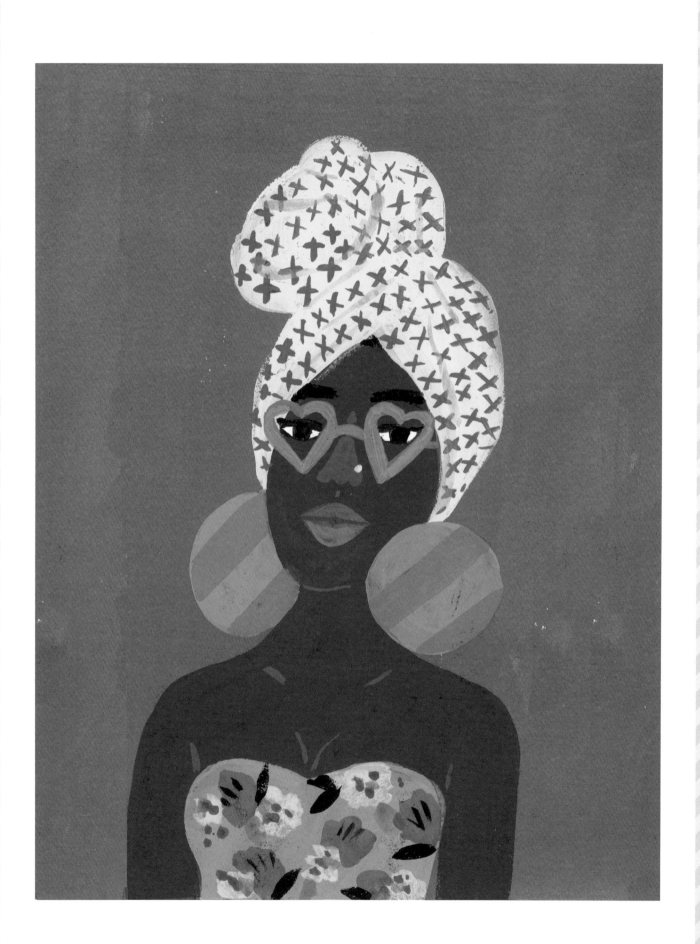